DAVID DONALDSON

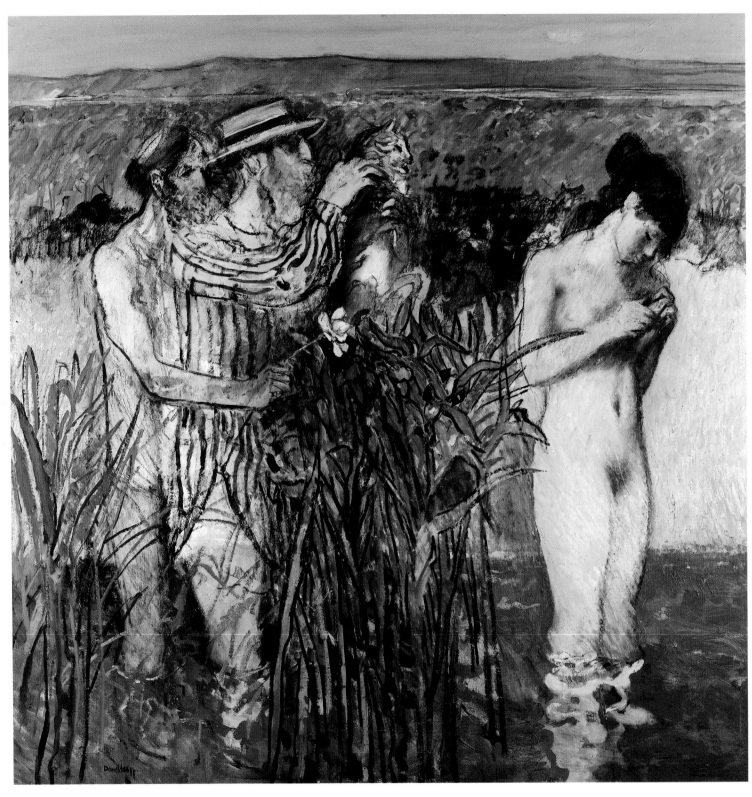

1. Susanna and the Elders,
1978–82

DAVID DONALDSON

RSA RP RGI LLD DLitt

Painter and Limner to
Her Majesty the Queen in Scotland

W. GORDON SMITH

MAINSTREAM
PUBLISHING

EDINBURGH AND LONDON

First published in 1996 by
MAINSTREAM PUBLISHING COMPANY (EDINBURGH) LTD
7 Albany Street
Edinburgh EH1 3UG

ISBN 1 85158 826 4 (hardback)
ISBN 1 85158 851 5 (paperback)

A CIP catalogue record for this book is available from the British Library

Photographs by Eric Thorburn (unless otherwise credited)
Designed by Janene Reid
Typeset in Adobe Garamond and Gill Sans
Colour reproduction by Global Colour, Selangor, Malaysia
Printed in Hong Kong by H & Y Printing

CONTENTS

ACKNOWLEDGMENTS

One thing is certain. Neither the publication of this book nor the eightieth-birthday retrospective exhibition of David Donaldson's paintings at the Talbot Rice Gallery, Edinburgh, would have happened without the dedicated support and dogged persistence of Barclay Lennie, of Barclay Lennie Fine Art, Glasgow. He, in turn, gratefully acknowledges the support he has had from Mark Read, Roger Billcliffe, Brendan Vallar, Christie's of Glasgow, Meg Ferguson, Brian Knox-Peebles, Stanley Hunter, David Donaldson jnr, and especially Anne Donald. I join him in thanking the private lenders of so many paintings as well as the University of Glasgow, Aberdeen Art Gallery, Antonia Reeve, Glasgow Museums and Art Galleries, the Lillie Gallery, the Open Eye Gallery, Sean Hudson and the artist himself for their pictorial contribution to my text, but reserve special credit to Eric Thorburn, who photographed most of the book's illustrations with his customary craft and sensitivity.

Arthur Andersen & Co, generous patrons of the arts in Scotland, gave substantial financial assistance to the whole 1996 Donaldson project.

I am personally indebted to Sandy Moffat for his graphic memoir of David Donaldson's days as head of drawing and painting at Glasgow School of Art; to scores of anonymous former students and colleagues who enlivened my research; to Anne Donald's original research in 1983 for Donaldson's major retrospective at Kelvingrove; to Judy Diamond (editor) and Janene Reid (designer) at Mainstream; to J.O. Wastle of The Scottish Office for his illuminating notes on the official history of royal limners; and, as ever, to my wife and professional partner Jay Gordonsmith for her constancy and undiminished zeal.

FOREWORD

David Donaldson RSA RP RGI is one of the finest painters Scotland has produced in the twentieth century. As a portraitist his best work deserves to be ranked alongside the paintings of his great predecessors, Ramsay and Raeburn. He is widely acknowledged as the creator of sumptuous still-lifes and idiosyncratic allegories, and as a landscape painter who has expressed the essential character of countryside in Scotland and France. Since 1977 he has been Painter and Limner to Her Majesty the Queen in Scotland. He has been honoured by the Universities of Glasgow and Strathclyde.

In his own words he is 'a wee bastard who was bairned up a close in Coatbridge' and born in 1916. Without any qualifications he entered Glasgow School of Art at the age of fifteen and left at sixty-five – still without formal qualifications – having been a legendary head of the department of drawing and painting for fourteen years.

The story of Donaldson's childhood – he attended his parents' wedding when he was at primary school and did not learn that they were his mother and father until he was in his teens – could be the stuff of the darkest Scottish fiction. The laddie who survived his disturbed background in a Lanarkshire steeltown, bleak with Baptist stricture and bigotry, grew up to paint the Queen at Buckingham Palace and Margaret Thatcher at Chequers, as well as many prominent figures in Scottish public life and a procession of beautiful women.

Since his early student days he has been obsessed by 'the immaculate grammar and beauty of paint'. Even on the threshold of becoming an octogenarian, he will talk for hours about paint – its character and texture, subtleties and mysteries. Donaldson speaks frankly and often belligerently about most things. Humour deckles the edges of his argument. He reveals himself as a cantankerous, warm-hearted, kenspeckle character who is seldom neutral about anything in life or in art.

You would not be many minutes in his company before you heard his

repertoire of curses. Donaldson uses the 'f-word', which every Glaswegian recognises as common currency and not the personal prerogative of James Kelman, as a decorative and targeted expletive, with none of the repetitive inanity of the football terraces. The 'c-word' is summoned more selectively, reserved for his most scabrous dismissal of someone beneath his contempt, and usually prefixed by 'fat wee' or 'stupid big' or maybe just 'effing'. He employs other, less obvious epithets – none more derisory than 'east coast', particularly if he is applying it to Edinburgh painters.

At a formal gathering in the Royal Scottish Academy not long after his election as an Academician, he found himself at one end of a salon, surrounded by visiting office-bearers of other artistic institutions who, it must be said, were enjoying his slightly outrageous patter. The president of the RSA, Sir Robin Philipson, whose personal charm and diplomacy did much to reduce the chronic animosity between Edinburgh and Glasgow, saw what was going on at the far end of the room and, knowing that the Glaswegian's sense of humour was capable of making mischief, gradually eased himself in that direction. Another

David Donaldson, 1992

burst of laughter followed another Donaldson sally. Philipson reached the group, radiating his customary bonhomie and concealing any anxiety he might have felt. He put his arm round the shoulders of his friend and told the distinguished guests: 'Don't believe a word this wee scallywag tells you.' And Donaldson roared back, 'Scallywag! Oh, that's very Edinburgh. In Glasgow they'd call me a wee cunt.'

Wee is a word made for the man. I am an inch or two over six foot tall. I have learned not to intimidate men of Napoleonic proportions by dwarfing them. I keep my distance. My wife claims she is an inch over five foot and, while I believe that inch to be a delusion, I have never embarrassed her with a measuring-tape. Nor have I ever asked David his height. When we meet at his house and say goodbye – which are almost the only times we see him upright – I give him his space, but my wife stands very close to him and they exchange a wee squeeze. On these occasions their eyes, noses, chins are directly in line.

Framed by the open doorway of his grand house, standing in its own grounds in the most desirable part of western Glasgow – Kelvinside, forsooth – he seems even smaller as he waits to greet you or acknowledges your departure with a cheery wave. His dress on these occasions is, to put it politely, informal; a shaggy jumper, pantaloon trousers, cosy, bootee slippers which are likely to be discarded during a long interview. An upright sitting position on the sofa very

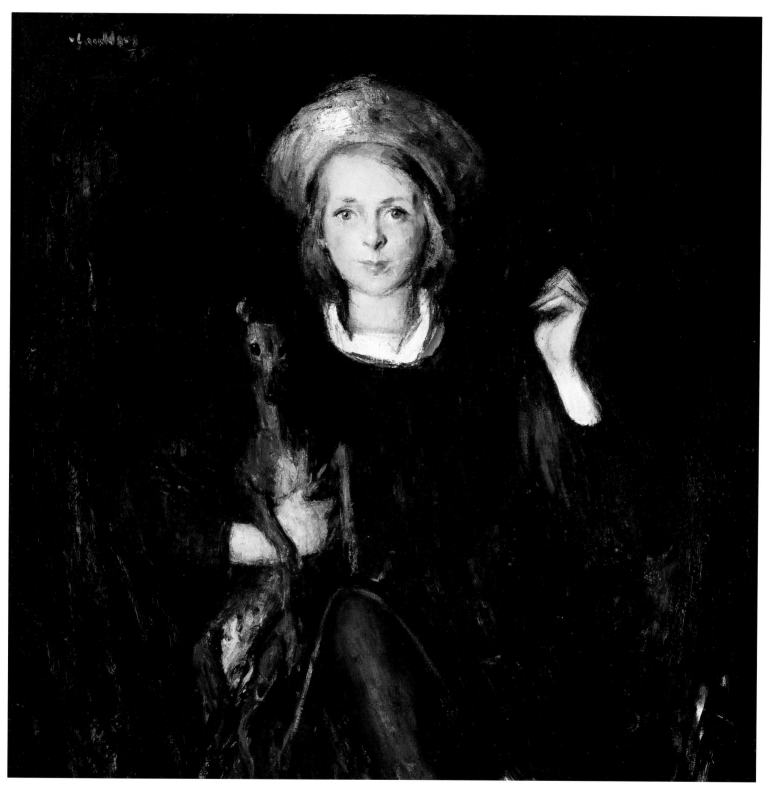

2. Maria and Ciao, c.1963

soon declines into a slouch before he abandons decorum, spreadeagles himself over the cushions, and lets his jumper ride up to his chest, exposing a hummock of belly. Chasing his mouth with the microphone was like casting for trout.

'Would you like a little more wine, Davie?'

'Aye, a half-pint will do.'

There was always a bottle of chilled white – 'Help yourselves.'

On parade, or out on the streets of Glasgow, he presents a different image – dapper, swanked in cunningly-cut double-breasted suits, silk shirts, hand-made shoes – making the utmost of himself. By holding himself very erect, and with a stillness that roots him to whatever spot he is standing on, by throwing his arms wide in a fixed gesture of salutation which will soon become a cuddle, by beaming you a big smile, eyes twinkling, and roaring some vulgarity in your ear, he seems pleased to see you. In the meantime, by sheer force of personality, he has increased his stature by at least six inches. Wee Davie, as he has been known throughout all of his eighty years, is actually quite a large man.

3. Two Glasgow Girls, 1981

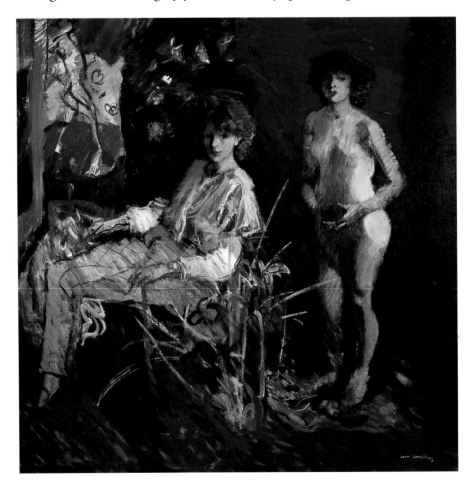

THE FIRST MEETING

If you were to believe every story David Donaldson tells against himself, you might also believe that an eternal monkey at an eternal typewriter did indeed write *Hamlet*. A combination of diffidence and a reluctance to be specific about many things persuades him to use banter and exaggeration, invention and hyperbole to avoid judgment in general and personal analysis in particular.

I came to this biographical account having had scant personal contact with the man. We had met in the street, spoken on the telephone, and I had often written enthusiastically about his painting. In 1971, when he lived on Loch Lomondside, I made a short film about him for BBC television. He generously ignored the handicap of my east coast origins and, in those days, my inadequate grasp of the theory and practice of painting.

For more than forty years I have heard many of the anecdotes, mostly outrageous – and the best, regrettably, apocryphal – which pour forth at the mere mention of his name. They are invariably comical, and imply that Donaldson is mean and generous, cruel and kind, bully and coward, bombastic and shy, Kelvinside snob and Glasgow keelie, irreducibly vain yet riddled with self-doubt.

Donaldson with his son and grandsons

When I arrived at his house for our first meeting to discuss this book, in the long hot summer of 1995, I was greeted by his daughter Caroline, who thought I was the police. Earlier that day a very expensive model jeep, which David had bought for his grandson Sebastian to sit in and drive about the garden, had been stolen. Donaldson's insistence that his front door should be kept open in daylight has encouraged many burglaries over the years.

David was unwell, as he has been for some time – very bright of eye and chirpy, mentally alert and vigorous, but physically depleted by the effects of diabetes. He was due to have all his teeth out in a fortnight's time. He wore a jaunty black-and-white polka-dot shirt and denim jeans. Toes peeped and wiggled out of a hole cut in one of his slippers.

I put it to him that the book should try to encompass the whole man, should avoid being a dry, academic analysis of his life's work, should embrace the character which had inspired all those wild stories without turning him into a cultivated clown. He agreed. Then thought about it a bit more.

DD You'll have to guide me on this.

GS *Joke, by all means, but don't turn everything to comic cuts.*

DD It will be difficult for me, but I recognise I owe what you say to many things.

GS *You owe it to yourself.*

DD I feel very guilty about these Glaswegian attitudes. We tend not to take ourselves very seriously – like my usual story about a painting, 'Of course, you know I just did it by numbers.' We tend to put two fingers up to everything.

4. Arrangement in White,
c.1975

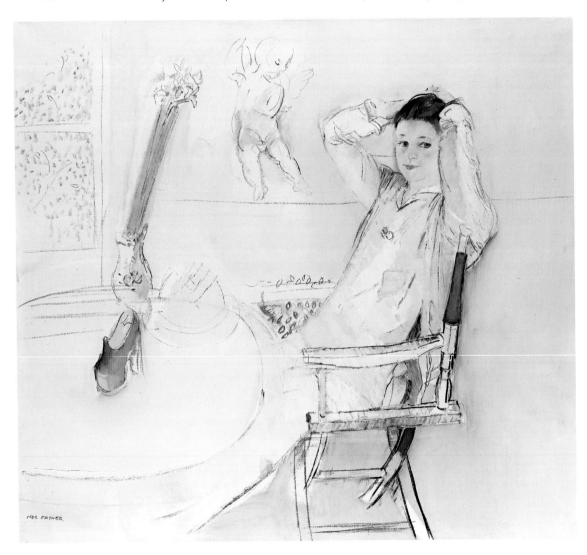

We're not like the people – and we all know them – who paint those atrocious paintings and put them in the Academy. They expect you to take them seriously, for Christ's sake. Glaswegians are very bad at putting on that kind of act. I feel sometimes that I should be standing at the easel and saying, 'I've thought days and days about this.' Fat chance! Is that serious enough for you?

GS *It's honest enough. I certainly don't hear David Donaldson in that mode.*

DD There is a real dichotomy, you know, between the facility for draughts-manship, for doing extraordinary things in a pictorial way, and what I mean by painting. Sometimes I really don't think there's any point in being what I mean by a painter. Scotland has made such a balls of talking about 'our painting tradition'. It would bore you stiff. As if there was even something especially Scotch about it. I remember John Byrne in his student days. John is not in the purest Scottish sense a painter. He's primarily a designer draughtsman, but nonetheless he can paint marvellously in the ordinary sense. I believe that I never taught him anything. I just hung around. But I remember watching him work one day and saying, 'That's good, John. Have you had any problems with it?' And he said, laughing, 'Not at all, Mr Donaldson.' He had just swept this picture in with a flourish. I thought then and I think now, 'What's the point?' And it will sound like sour grapes. So would you guide me, because I can play this silly game so well.

GS *I'm discouraging you from playing any games. Some of that side of you has got to come through, but sending yourself up does no good whatsoever. There has to be balance, and I'll impose it if necessary. Too much of your Glasgow cynicism would be dangerous. You don't mean it, you're just showing off. Nobody believes that you are the kind of painter who slashes away at a canvas and says 'That's good enough for the Academy, bugger it.' That's not you. But it goes on. I don't know a single painter who doesn't stand in front of a canvas and say, 'God Almighty, have I got to scrape this off because it's not working?' The trouble is that so many of them leave it on.*

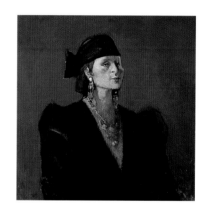

5. Marysia II, 1985

We agreed to talk about his private life, his marriages, his extraordinary childhood, his fifty-year stint at Glasgow School of Art, how his painting developed over the years, his attitude to teaching and his contemporaries, and the influences which had helped to fashion him as artist and man. No holds barred – that was agreed from the beginning. He welcomed that approach.

Nevertheless, I felt we should establish more precisely to what extent my

questions and his answers would embrace his domestic life. He married Kathleen Maxwell, 'an extraordinary girl', in 1942. After early happiness and the birth of a son they went their separate ways and subsequently divorced. In 1948 he married Marysia Mora-Szorc, a designer and painter who, for over forty years, had a huge influence on his painting life in a mercurial relationship which produced two daughters. They have lived apart for some time.

'We'll be as truthful as we can,' he said. 'Basically there's no need to be anything other than truthful. There's certainly no need to be hurtful.'

Some days, in the course of eight two-hour recording sessions, he was not in the best of health, but he never prevaricated, never ducked a question. He resisted invoking Oliver Cromwell who, when having his portrait painted by Peter Lely, instructed him to 'remark all these roughnesses, pimples, warts, and everything as you see me'; but from the beginning I was left in no doubt that 'warts and all' was his wish.

Indeed, that confidence formed for the first time in my mind the idea that I was painting Donaldson's portrait. This would be no trawl through gossip and the writings of others. The facts of his life would have to be verified, of course, and I might solicit the views of a few of his peers and close associates, but I had been commissioned to take my equivalent of easel and canvas, paint and palette, and reveal the man as I found him – as I saw him and, at our many sittings, as he revealed himself to me. He was not the first portrait painter to tell me how some of his subjects, out of nervousness or a curious need for intimate communion, had revealed themselves as if under a compunction. My hopes rode high.

For seven of the recording sessions we stayed in the drawing-room, an elegant but unpretentious Victorian salon, high-ceilinged, hung with his own paintings, scattered with pieces of sculpture, every surface bearing bric-à-brac, photographs, bits and bobs from antiquity which his magpie mind had encouraged him to acquire as 'unconsidered trifles'. A grand piano in the room and his frequent use of musical imagery to illuminate the language of paint suggested that he might, in fact, play the instrument, but the ferocity of his denial suggested that a great love of hearing the piano played beautifully was sufficient discouragement.

There were several reasons why a visit to his studio on an upper floor was delayed, time and time again. He made it obvious that the physical exertion of painting – particularly covering a very large canvas – was almost beyond him.

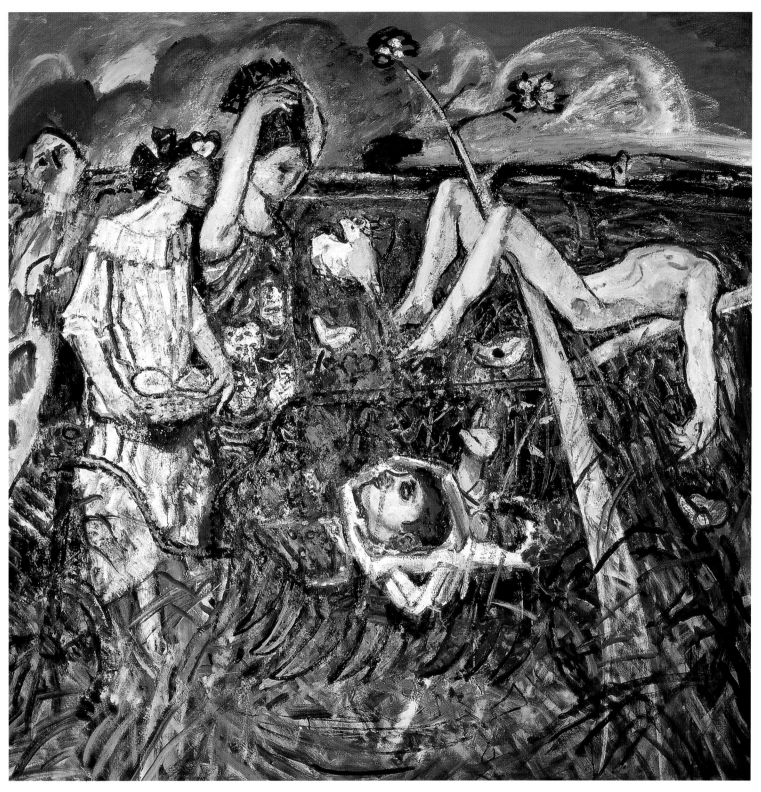

6. Judith and Holofernes, 1995

Even getting up the staircase to the studio made severe demands on his feeble strength. I also believe that he had lost confidence in himself. The frequently uttered 'I cannae paint any more' had more to do with some despair he felt when he reached the top of the stairs and came face to face with what he had so far achieved than the effort it took to get there. A few weeks earlier he had put the last touches to a still-life, a rich little gem that looked as if it might glow in the dark, finished in time to be shown in Sandy Moffat's 1995 exhibition, celebrating so splendidly the 150 years since GSA's foundation.

The day came, however, when with a metaphorical fanfare and roll of drums he announced on my arrival that we should go straight to the studio. It was, I have to say, the tidiest working studio I have ever seen, but comparative inactivity rather than a compulsive sense of order could have explained a cleanliness that was almost clinical.

On one of several easels stood a huge canvas (Plate 6). On a chair nearby was propped a Donaldson sketch, dating back to the 1930s, which had been the inspirational source of the big biblical allegory in front of me. The Burrell Collection was in the process of paying £300,000 for Cranach the Elder's 1530 depiction of *Judith with the Head of Holofernes*. The same grisly tale from the Apocrypha had, coincidentally, beguiled Donaldson. I could see why its scale, subject and treatment had daunted but not defeated him. Judith had saved her nation by assassinating the captain of Nebuchadnezzar's army before the walls of Jerusalem. He wished his 1995 painting to be at the heart of his major retrospective exhibition in June 1996 – his eightieth birthday celebration at the University of Edinburgh's Talbot Rice Gallery, one of the finest venues for contemporary art in the land.

'Is it finished?' I ventured to ask.

'I think so . . . Is anything ever finished?'

'Will you be offended if I tell you not to touch it, don't dare lay a brush on it?'

I was emboldened by remembering a scrap of paper which has been in my possession for some time. It was given to me by a former pupil of Donaldson's, now an established Scottish artist, who – as students will – sought to find her own painting style by being Van Gogh on Mondays and Renoir or Botticelli on Thursdays and Sundays. On this day in the 1960s, alone in a GSA studio, she had decided she was a Fauve and set about a self-portrait in the manner of the wild beasts – an aggressive head in reds and purples and greens. She had got to the stage of not knowing whether it was finished or not, worked in any way as

a painting or not, and as she went off to the lavatory was of a mind to scrape the board clean when she got back. She was away from her easel for only a few minutes. A torn-off fragment of paper with a pencilled message was stuck to the wet paint – 'Very good, Donaldson' it said, and when she saw him he insisted that she should not touch the painting again. She told him how worried she was about her progress. He said, 'You'll find it lonely, but you must honour your own talent. Michelangelo's deid, and it's your turn next.' She sold the painting but kept the note.

We were still standing at his big new figurative allegory, so complex compared to Cranach's gory realism. 'I've ordered a bloody expensive frame for it, anyway.' He assured me he would leave it alone, and I wanted to believe him.

<center>❀ ❀ ❀</center>

The early interviews went well. He was relaxed, fluent, tried very hard to hold on to threads of thought, but kept encountering tantalising diversions whose relevance to the current theme emerged only after a tangle of anecdotes, scurrilous asides and character assassinations. We laughed a lot.

There was a brief break in our recording schedule while he braved the dentist's couch. Within a week he had bounced back, in spirit at least, and never complained. 'How have you been, Davie?' was invariably answered by a grunt, a scrub of his bald pate, and a philosophical mutter about 'this diabetes'.

Throughout my professional life in Scotland I have found the rift, gulf, schism – call it what you will – between Edinburgh and Glasgow at best boring banter, at worst a destructive, poisonous and artificial divide. As an Edinburgh man I was hailed as 'the man from the east' by BBC commissionaires in Glasgow who, in these circumstances, should have frisked me for frankincense. Their executive superiors, working like me under the 'nation shall speak peace unto nation' banner, should have known better. Glasgow newspaper editors behaved belligerently, as if I were a tax inspector investigating fraud. Glasgow artists, on the other hand, betrayed a sense of inferiority in more obvious ways – by a wily curiosity about Academy painters and how they fared in their eastern market-place, gleeful displays of *schadenfreude* when the news was dire, and huffed like schoolchildren excluded from a gang.

Donaldson is different. Nothing defensive about him, no shilly-shallying, straight in with a boot which is, in reality, a carpet slipper. He seemed to use the

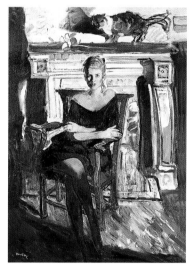

7. Krysia and Rosie, 1989

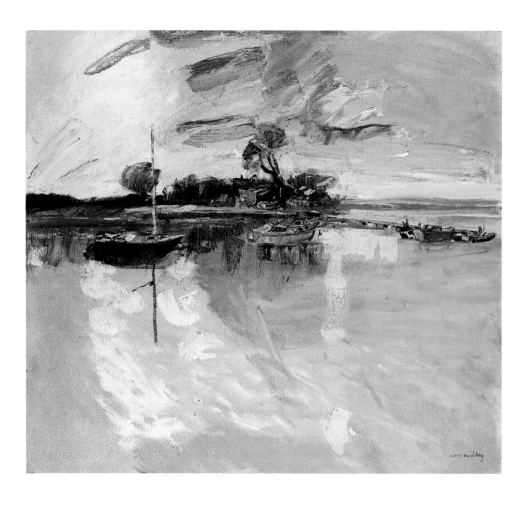

8. Loch Lomond, c.1974

phrase 'east coast painters' as the zenith of his contempt. I came to realise that there was no malice in him, that he could puff up a balloon of invective then burst it with a laugh at his own expense. As evidence of his inherent good will, he was delighted in 1986 to collaborate with the Fine Art Society in an exhibition which was mounted in Glasgow and Edinburgh, *Donaldson and Philipson at 70*. The artists painted and, as always, enjoyed each other. Donaldson's reservations about the ability of east coast painters can be applied with equal ferocity to his friends and brother-painters in the west. He made no specific attacks on women painters, but he has been known to mutter that too many of them had 'hairy chests'.

The painter he is most likely to denounce is himself, then declares that he is the best of the whole bloody bunch, second to none, and don't dare doubt it.

THE CHILDHOOD YEARS

Even the baldest outline of David Donaldson's childhood sounds like the sub-plot of yet another fictional descent into the dolour of Scottish working-class misery between the century's two world wars.

He was born on 29 June 1916 – as he says, 'round about the day the first Battle of the Somme was begun'. As an art historian, which he affects not to be, he might have noticed that Odilon Redon died that year and that Matisse painted *The Three Sisters*. But like all Scottish boys who grew up in the aftermath of the Great War – as it was called until the world tore itself to pieces again – that terrible conflict, and the tragedy it brought to every village and hamlet in the land, sent a shudder through their lives when they heard mention of the Somme or Ypres or Passchendaele.

'I was a wee bastard who was bairned up a close in Coatbridge.' That, I repeat, was precisely how he began his story. 'Since I was being born out of wedlock the event had to be kept out of the local public eye.' The record states that he came into the world, albeit secretly, 'in a farmhouse, I think' at Chryston, a village near Coatbridge.

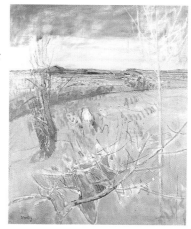

9. Early Spring, Duncryne, 1981

GS *Your mother wasn't married?*

DD My father wasn't married either.

He talked about being born into 'an industrial landscape of the mind'. A strange assortment of folk – 'Lanarkshireish, steeltownish, Church of Scotland, Baptist and all those other people who were not Roman Catholics, folk who covered up everything they were doing'. His father's parents, faced with the disgrace that their son had 'bairned' somebody, said, 'Get this business to hell out of here; put it out of sight.' In those days they knew that naughty things went on up closes, but the consequences had to be hidden.

The infant David Abercrombie Donaldson was then 'spirited away' to Loch-

winnoch, on the other side of Glasgow, 'and it came to pass', as he is wont to say with heavy pulpit emphasis, that for four years he was brought up by foster parents called Allan. He knows nothing about them, remembers nothing of the years with them which left him 'with a hole in my head where part of my life went down the stank. There's something of my time with them still with me, some unconscious memory, but I've never known what it is. As a consequence the concept of father and mother has given me great difficulty. And I, in turn, was never a good father.'

By some unknown social adjustment he was returned to Coatbridge at the age of four and brought up in their council house by his father's parents. His grandfather, 'old Dave Donaldson', was a steel-roller in the Coatbridge mills.

It was all a bit Dickensian. Around the age of eight I began to believe that all was not quite right. There was always a whispering. Old Mary, my grandmother, was quite a girl. Whenever the auld wives got together there was a lowering of voices and I felt something was far wrong. I had no clue what it was. The whole story is so sordid and sad, yet some bits of it were wonderful in a way.

Not knowing who his parents were became even more difficult when the old Donaldsons – 'let's call them that' – took his mother Meg into service as a housemaid and skivvy 'in a Coatbridge council house, for Christ's sake!'. (He couldn't resist the aside, 'What will they think of that in Edinburgh – in the Royal Scottish Academy?') So far as the wee boy was concerned the woman who came to the house every morning and 'dusted the curtains or whatever skivvies do in Coatbridge' was just a woman called Meg. He believed that the man who lived in the house, Bob Donaldson, was his big brother, but of course he was actually his father.

Donaldson admits that he has had to use his imagination to understand why his mother was brought into the household. Fierce social distinctions operated between working-class families.

On the ladder of ascension old Dave Donaldson was a big shot – a wee big shot – and my mother's father was not such a big shot. When she came to work in the house it would be nice to think there was a bit of conscience-healing going on, but I have my doubts about that.

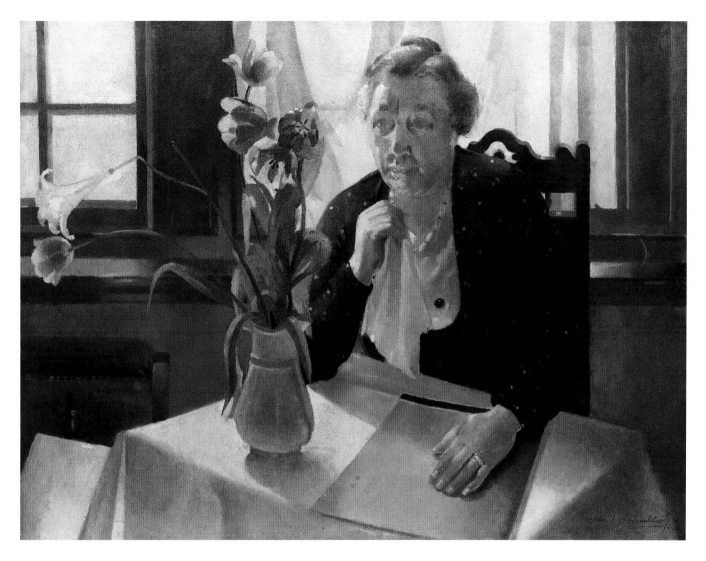

So far as he was concerned, Meg simply came, did the work and went. He remembers no special, let alone maternal, relationship with her.

One night, when he was eleven, there was a terrible row in the house. Old Mary, his West Highland grandmother – he remembers her as a fine raconteuse with a fiendish temper – set about her son Bob with a tirade about the amount of money 'that slut' had cost the household, how she had 'soiled him' and how 'by sticking by her' he had wasted his life. 'It was wonderful to behold, but frightening, dreadful. Meg was there. I just stared at the gas mantle. There was nothing else to do.'

The next day wee Davie was dressed up in his Black Watch kilt and taken to the wedding of two persons he knew, but it was years before he was told they were his father and mother.

You'd have thought that some person would have said – 'Dear Dave, come to your mother and father's wedding' – but there was none of that silver writing on a nice invitation. I remember the lights in the church, and the glinting of my kilt jacket buttons, and the folk on the other side of the church – from my mother's side of the family – who belonged to a slightly lower social caste. I looked like a midget from a pipe band. If there was any celebration after the nuptials I don't remember a thing about it.

The married couple – the people I thought of as my big brother and the woman who cleaned the house – went off to live in their own council house and I went home with the old Donaldsons.

A few years ago he was asked to give an account of his childhood for a Coatbridge charity project. He scavenged about in his head and put together a cheerful account of a young life which will touch familiar ground for several generations of Scots – impressionistic recollections which, like so many memories, have been distorted for the better by the healing process of time. I have edited his essay to suit this book's purpose.

My childhood and schooling shaped me to be an outsider. Not that I wished to be. I was anxious to be accepted. Regretfully, I seemed unable to interpret rules correctly, a difficulty that experience has not overcome. School was a trial. Counting beyond ten made my life a misery. Happily, being a child at Coatdyke Primary School was not just a dreary round of ill-understood arithmetic. How could it be, when Corky Lovell was headmaster – so-called because he had an artificial leg. Totally Victorian, complete with velvet jacket and velvet smoking-cap, peering through steel-framed glasses. He was kind to wee boys with diarrhoea or any other ailment, treatment for which was dispensed in his room – senna tea, poured out into a saucer and, the ultimate consideration, blown to an acceptable temperature. Corky understood, too, the need for surprise half-holidays. Perhaps his leg ached, or maybe he had run out of senna tea.

Tumult and shouts at playtime. Peeing over the wall. Lucy Gray and Sir Patrick Spens in the afternoon, while later in the gathering darkness the janitor lit the gas lamps. Then singing songs from Shakespeare – *Come away, come away* and *In a cowslip's bell, I lie* – as a correction to joy.

Most of us had boots, but there were those who arrived at school with

bare feet. In such cases, boots were supplied every so often (belated thanks to the Education Authority of Scotland, which walled us in with concern).

My family, being artisans, lived in a larger house than the single-ends allocated to the 'roughers'. Here lived those who kept 'pouters' (pigeons) or made the Houses of Parliament in fretwork from thick six-foot egg-boxes, still stained by the occasional broken yolk. These same egg-boxes doubled up as children's beds, hauled up by pulley to the ceiling during the day. One 1914 soldier named his daughter Mons, after the battle in which he fought. Another went mad and was taken away and shut up, after bringing a herd of cows to graze on the back-greens of some houses.

There was wonder, too, when the great black horses and hearse came into the street to act out the Victorian drama of death. It was all clatter in those days – horses drawing milk carts or 'mickey carts' (cleansing department), all traffic loud on iron wheels on cobblestones, and manure being gathered with a shovel. 'Katie with the Iron Teeth' and 'Jock with the Hairy Waistcoat' were minor human demons introduced into our culture, bringing spice and exhilaration. The fear was enjoyable.

We climbed the social ladder to a council house up-town. So, too, I advanced to secondary education, and to the Scouts. I went off to camp a few miles outside the town, staggering under the burden of a huge kit-bag, supporting the popular conviction that solidity and weight meant worth. The experience of that first night! Wide-awake till dawn, lost in the beauty of the green light flooding through the tent. There was porridge in the morning, immovable in the billy-can; later that day, custard, turgid and congealed, with grey ash dropping like impetigo on the sulphurous yellow skin. I preferred to have it with stewed rhubarb, similarly sprinkled with ash.

Secondary school opened up a vast academic minefield, wherein any hope of a polite and profitable career was instantly destroyed. But there were survivors, and their achievements throughout the world bear testimony to the excellent teaching that was available to us all. Nor was the art class a haven for me. Shading and assessing the contours of a jam jar found me woefully inept, and jealous of those better able to understand the rules of the game. I realise now that on my part there was a resistance to organised teaching, and that my dreams had other values and disciplines – like being a drummer in a jazz band.

In such a steeltown, the sub-culture was lurid – much of it, as no doubt it still is, concentrated below the navel. Squeals in the dark, trigonometry

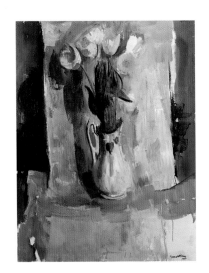

11. White Tulips, 1964

forgotten. The swimming baths offered other hazards and delights. On a Friday, the entry was one penny, and we splashed in a broth of water, on the surface of which floated, forlorn and sodden, corn plasters and tramcar tickets. Threepence on the Saturday bought clean water, but at a price. Broken biscuits, from a nearby bakery, satisfied hunger after our exertions. A few coppers had bought a day bright with incident and substance.

Religion meant Sunday School – another infringement on one's liberty. Scrubbed and dressed you arrived at the Baptist Church with a penny for the plate. Tedium and disbelief. The rest of the Sabbath was calamitous with boredom, for everything was forbidden. No running, no bike, and stewed rabbit for tea. I refrained from reading *Pilgrim's Progress*, and sought diversion and information in the family medical book, wherein 'pop-up' lungs and intestines sprang to life with a most edifying display. It was probably this required reading that influenced me to consider medicine as an alternative to boredom.

The Baptist Church offered other routes to salvation. I sat among the congregation of black-clothed ladies on soirée nights, whose men were safely exposed to the dangers of white-hot iron on the night-shift. Listening to the minister, listening to the rustle of sweetie pokes, awaiting the arrival of tea in brass kettles, new-burnished for the occasion, resplendent with blue bows. Waving to friends across the holy sea, as we waited for the main event, a convert from Glasgow, playing a selection of sacred melodies with milk bells. There was hushed admiration as four bells were rung to strike a chord. Rock of Ages. Admiration, too, how the bells were silenced on a baize table.

There was no formal response to this kind of litany such as may exist in other churches. But on the occasions that I witnessed, it was to rise and sing with stout conviction:

Nothing to pay,
No, nothing to pay:
Straight is the Gate
And narrow the Way.
Look ever upright,
Start right away,
Coatbridge to Glory,
And nothing to pay

Another cup of tea from the kettle, and straight into:

> *We are travelling to the Mansions*
> *On the Happy Day Express,*
> *And the letters on the engine are*
> *J.E.S.U.S.*
> *And the guard shouts, Off for Heaven?*
> *And we gladly answer, Yes,*
> *We are travelling to the Mansions*
> *On the Happy Day Express.*

Then a sincere good blessing, and out into the night to hear mothers and grannies discussing their operations past and to come, legends of pain endured, devoted championship of various local doctors, and proud boasts of visits to the Glasgow Royal [Infirmary] for whispered diseases. With this kind of medical background so easily available, I invalided myself out of the education process at one point. The surgeons at that great hospital took out my appendix and showed it to me next day – brought it to me in some surgical silk bag as a treat. Maybe it wasn't mine. Who knows?

He wanted to expand on that hospital experience and reveal how a true romantic could take something beautiful out of an unpleasant experience.

Getting your appendix out was a serious business in those days, a fortnight in the wards, castor oil every night. The Royal was wonderful. It was still the tradition that nurses were ladies of the lamp, women of the manse. I can remember a ward sister singing quietly in Gaelic to the patients at night. It was bloody wonderful. I thought she was dressed like an angel, and if I was going to die, I might as well die like that.

After his spell in hospital he did not return to school. 'I was a complete dope. I couldn't cope. It was tragic.'

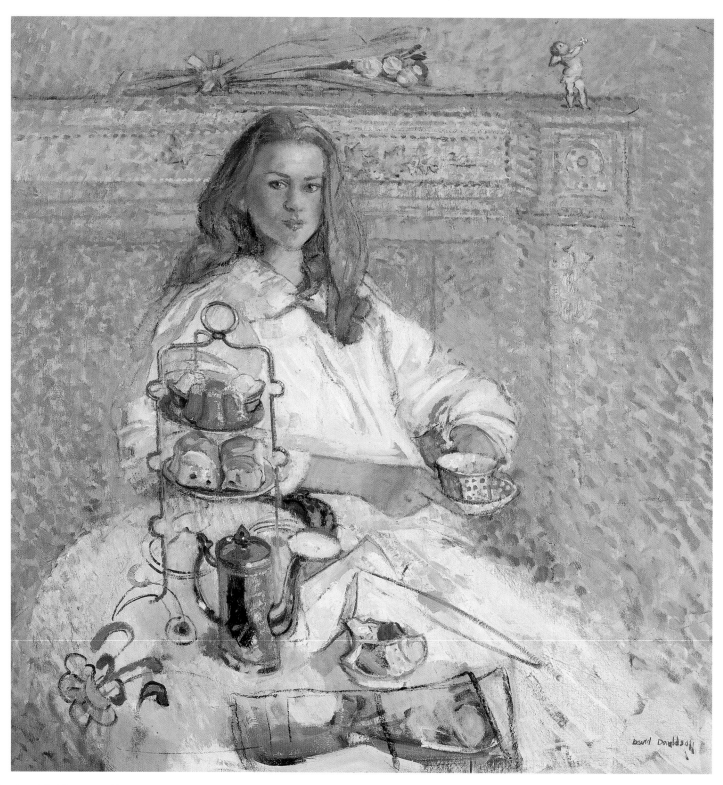

12. Krysia with Afternoon Tea,
1985

THE SCHOOL OF ART

The act of getting into art school is one of several 'grey areas' in his life. He saw the place as a launching pad for 'a flight from reality' and was admitted with neither bursary nor educational qualifications. In 1931 – as he recalled in a contribution to Glasgow School of Art's official history, published in 1995 – the city was alive, vivid, 'something like a blueprint for Chicago, and while other cities no doubt felt the same, Glasgow felt it better'. Merchant city Glasgow would go a long way towards recapturing that vitality in Thatcher's 'yuppie' culture half a century later.

Donaldson admits that up to the age of fifteen he did not know that such a thing as a school of art existed. When he was about twelve or thirteen somebody had given him a book on fine arts – Sir William Orpen's *Outline of Art*.

> It was a sad book. I've never known what fine art is, anyway. But it was a beautiful edition with wonderful pictures. And I just dreed myself through it – and I still do. An Edinburgh girl, an art teacher, suggested I should go to art school. I can't think why. Also, I had acquired a kind of uncle person, a Baptist minister. A family council decided that he should take me to the school of art. And he did.

Glasgow School of Art, one of Europe's most prestigious centres of art education, celebrated its sesquicentenary in 1995 – a pretentious and not very Glaswegian way to say that it had been going for 150 years. It was begun as a Government School of Design, and as an aid to local industry and the development of teaching in the fine arts. Crafts joined the school's ambit towards the end of the nineteenth century as well as the creation of a full-time school of architecture. By 1901 GSA was an independent educational institution awarding its own diplomas. In 1902 the school occupied the first half of the building it still inhabits – acknowledged the world over as the masterwork of

architect and artist Charles Rennie Mackintosh, GSA's most famous pupil.

By the time young David arrived, GSA was established as one of the finest teaching establishments in the land. Foreign journalists came, saw, and sang its praises. It had taken time to recover from the trauma of the First World War, but by the early 1930s had re-enhanced its reputation.

I was not well received – and no wonder; I had none of the right things, nothing at all to recommend me. The secretary of the school – who, incidentally, had only half an arm and later absconded with the school funds – decided that I should go into some hideous thing called commercial art because I was such an obvious idiot.

I couldn't do the things they wanted. You were drawing these people sat astride a Bovril bottle. Advertising. It was anathema. I cried the first day I went home. Someone asked recently what I did in those days and I said I played tennis a lot and lusted the rest of the time. I failed my commercial art certificate. I played tennis that day. The whole thing was just bloody crazy. Many other people enjoyed themselves putting the highlights on Bovril bottles.

It was murder. A dream died, and I still feel that very strongly. It was a dream utterly shattered. Where was Rembrandt in that place? There was no Giotto. It was all a mess. Of course there was all sorts of charity and kindness. One old girl started to teach me life-drawing. I never could and still can't understand why we do life-drawing. I can't do it. I don't know and nobody has been able to tell me what you did it for. It's just a facility that can be judged. In a way, I've been grateful for all that madness, stupidity and confusion. At the end of the day it enabled me to save the dreams of a lot of people.

We used nothing much more than poster paint. Students were mostly downbeat working-class kids who couldn't do anything else, and smarty-pants West End girls waiting for a rich boyfriend. That was about it. On the other hand I realise now there were ghosts in the air. I think maybe this was peculiar to Glasgow . . . I've been only twice in Edinburgh College of Art, once in Dundee, and once in Aberdeen. I couldn't be bothered going again. But we had ghosts in Glasgow. The place was impregnated with the shades of Greiffenhagen and all that bunch. All the big boys had been there, left their mark. This was something you learned. Later on I said it was the cheapest finishing school in Europe.

The great thing was my fellow students – just talking to them. And

Glasgow was exciting after Coatbridge. Historically it was an interesting time. I realise now that it was the beginning of the emancipation of the working class – their first real chance of tertiary education.

The school had been designed for its purpose, to teach the principles of our trade, and like Glasgow itself, it was sternly beautiful and practical, scrubbed by a cohort of cleaners, presided over by our janitor Mr Letham, resplendent in a green frock-coat and, on special occasions, a green top hat. The staff were superbly talented and properly distant, not yet in thrall to an education system that demanded their accountability, or so it seemed. There were happy diversions like the annual Christmas Ball, an out-of-season Midsummer Night's Dream which gave us all a chance to be other than ourselves. Some, of course, continue with that delusion to this day.

Towards the end of his first year at art school a gifted stage designer and lecturer Dorothy Carleton Smyth – 'a great Glasgow girl' – who had been selected to succeed John Revel as director of GSA, suggested that Donaldson should be moved to a more appropriate course in his second year. When he returned to school after the summer break Smyth had died and he was left 'hanging about' again for another year.

Life-drawing and painting was the *raison d'être* of most British art schools and Glasgow imposed it as a severe discipline. Donaldson hated drawing – 'absolute bloody agony' – but looked forward to the two afternoons a week when, under the eyes of artists like Somerville Shanks, he was coached in life-painting. Shanks had worked as a pattern designer for a curtain manufacturer and after evening classes at GSA had studied in Paris. By 1934 he had become an Academician and his robust painting style of still-life, portraits and figures in interiors – influenced by Manet – had become popular in Scottish salons.

13. Pattern of Flags, 1933

There were many interesting people like Shanks around. Really super painters. They brought me alive. And they really taught you. They just said, 'Oh no, Mr Donaldson!' – and they called you Mr Donaldson – 'That is not correct.' And they just whooshed in the bit that was wrong. Just like that, no problem. It was brilliant to see somebody suddenly drawing something with a brush and *woof!* there it was. That, of course, was the Glasgow tradition. Wonderful. The rest of the time, as I say, I just hung around.

It is difficult today, when educational regimen dictates even art school teaching systems, to comprehend the laxity and apparent aimlessness of his student days.

> I had only one examination, which I failed. If there was a system, I wasn't in it. I was tolerated because old Dave Donaldson had paid my fees – not a lot of money – which entitled me to wander through a course, or no course, learning what and when I could. It was brilliant. And I would still support the idea. I still think that's the right thing to do.

I tried to put him on the spot. At twenty-one or twenty-two, when it seemed that his art education was at an end, when he would have to give up a life of indolence, lust, tennis-playing and occasional work, when he came out into the real world, what did he think he was going to do with his life? 'I don't know. I went in at fifteen and, as it happened, never went away.' So how did he manage to stay on? 'Well, the Lord, in his infinite wisdom, does things.'

Any attempt at a detailed chronology of Donaldson's life, particularly his early life, is a serpentine challenge. There is no deliberate evasion, no wish to obscure or dissemble, but over and above the time-and-age memory factor, he seems not to have marked the events of his life, erected few milestones on a long road. We had, however, reached one – a big one – and whether the Lord, who is beseeched frequently, or luck, or any other phantom agency had much to do with it, neither he nor we will ever know.

Enter William Oliphant Hutchison – an east coast painter, forsooth. W.O., as he was known, had become a parody of the Chelsea artist-chappie despite his Kirkcaldy origins, and was director of GSA from 1933 to 1943.

14. Continuity, 1935

> Bill Hutchison, who got the job destined for Dorothy Smyth, was crucial. He had colossal style and demonstrated how the rest of the art school was failing so miserably. He more or less awarded me a post-graduate course although, of course, no graduation had taken place. I got a studio. 'Of course you can have that studio. Don't mention it . . .' It was *droit du seigneur* kind of talk. And time just drifted on. I was encouraged to mess about with an entry for the Prix de Rome.
>
> One of the things you had to do for the Prix de Rome was copy an Old Master. That was probably the finest thing that ever happened to me, because

I knew how to do it. I have always been interested in how to do things. I painted *St Victor with a Donor*, one of the panels by the French Master of Moulins (Plate 15). It was very instructive. That year they decided entries were so rotten the prize was withheld. But somewhere it was said that this Donaldson lad was worth watching.

Hutchison was a most extraordinary man. He gave me his patronage, there was no other word for it. I don't know how the hell I achieved it, what I did to deserve it, for I was still just hanging about. Don't forget there was the rumblings of a war and it didn't seem so long since the last one. For the first time at art school I was really enjoying myself. I had found a home for lost dogs . . .

You were asking about my diploma. The more I think about it, the more I realise that the question didn't arise. I wasn't there to win a diploma. I thought the idea was to learn to paint like Goya or Rembrandt. Like the paintings I had seen in Orpen's book. That was my ideal. It is still.

15. Entry for the Prix de Rome – after Maître de Moulins, 1936

This was the first time in our conversations, I said, that he had admitted a desire to paint, almost acknowledged something in himself that needed kindling, nourishment, encouragement, as if it were a compulsion. He said my premise was incorrect.

I've never seen myself as a painter, as we generally accept the term. We all go around making assumptions about ourselves and we're never very clear. I'm not very clear about my attitude to anything. I envy those people who have a conversion on the way to Damascus and suddenly become painters. It didn't happen to me. There was no clear and direct feeling, all of a sudden, that I knew what I wanted to do. And yet, when I was copying that Old Master I must have acquired some sort of skill to do it, but how I don't know. It's as if something's been excised from my brain. Like somebody who's got dead drunk in the centre of Glasgow and suddenly sobers up somewhere else. When I looked at Orpen's pictures on the kitchen floor I had no wish to draw or copy them. I just liked them and absorbed them. At primary school, drawing was a right bastard because all the wee weans could draw carrots better than me. Nothing spoken meant anything to me. I seemed to live in a closed world with a closed mind. Like the Jesuits, or a trades union thinker.

Sir William Oliphant Hutchison, RSA RP PRSA VPRP – as he would become – had the gift of recognising artistic ability and the generosity to nourish and back his hunches. Instead of trying to fit the square Donaldson peg into the round GSA hole, he encouraged the young man to be himself, to learn how to express himself, and supported him socially and even financially.

He had tremendous presence – a survivor of the Somme, as it happens. A very handsome man. I think he had his own money. He gave the impression of using his director's salary to buy matches. I remember him telling me what a dreadful time he'd had just after the war in Chelsea when he and his wife were living on ten pounds a week. You'd heard of people living on that kind of money, but they lived in the glossy magazines. As people said at the time, Bill had 'a good war' and was well connected. We assumed that a scar across his ear was a Heidelberg sabre scar, but it wasn't – a German shell did it. Then there was his gorgeous wife, one of the Waltons – E.A. Walton's daughter. He had gifts in abundance. People became concerned and involved in what they were doing. It wasn't a hothouse for Bond Street, but it was a rather lazy and beautiful idea of life in a spacious age. I suppose Bill Hutchison had nothing to do but write the odd letter, and he was exercising his formidable talents as a socialite, with Glasgow School of Art part of the scene.

Donaldson is quick to acknowledge the influence of two distinguished tutors at this time. Hugh Adam Crawford had returned to GSA to teach in 1925, having studied under Maurice Greiffenhagen and Forrester Wilson in 1919–23 and then for some time at St Martin's in London. Ian Fleming studied at GSA in 1924–29 and developed a lifelong enthusiasm for lithography, engraving and colour woodcuts. He travelled throughout Europe and returned to his native Glasgow to teach in 1931. He became one of Scotland's most distinguished etchers and painters. Crawford, as well as being a fine portrait painter and social realist, is now recognised as having been one of Scotland's greatest art teachers. Donaldson, Colquhoun and MacBryde, Margot Sandeman, and notably Joan Eardley regarded him as an important mentor.

Donaldson's self-portrait *Me* (with a chamber-pot on his head) – a clowning conceit of himself, a study of alienated and disenchanted youth – was painted in 1935 (Plate 16). That same year he painted 'old' Mary Donaldson in a simple interior (Plate 10). Both portraits are in their own way stylish and owe

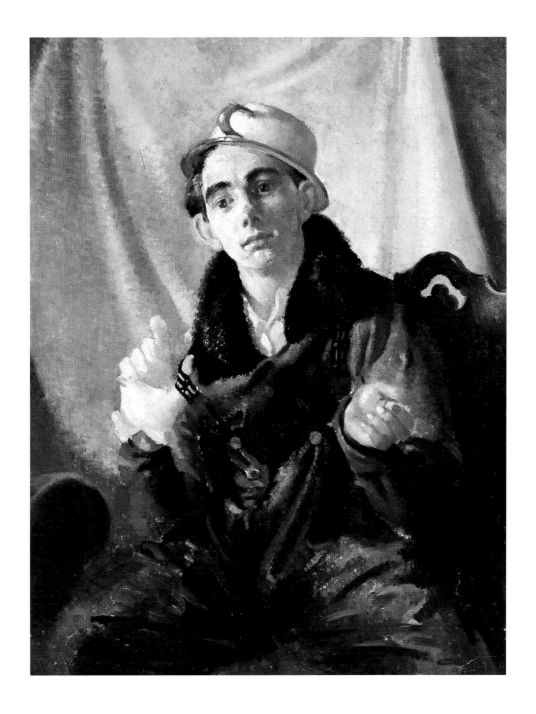

something to Crawford's encouragement of boldness and tonal harmony. The 'chanty' picture, for its audacity as well as its quality, amazed staff and students alike. Donaldson had set it all up – pantaloons from a student rag, a smudge of greasepaint on his nose and George Robey eyebrows, and the chamber-pot bought, after trying it on for size, in Sauchiehall Street Woolworth's. His air of aloof independence came naturally. Ian Fleming was quoted as saying that it was

17. Allegro, 1934

'an astonishing performance by any standards'. He also regarded Donaldson as the outstanding student of his generation. The presence of Fleming as a master engraver and printmaker also encouraged Donaldson to teach himself etching, and when he loaned GSA's 1995 'The Continuing Tradition' exhibition his print *Allegro* (Plate 17), etched in 1934, his repeated denial of skill in draughtsmanship was seen to be spurious. Hutchison awarded him GSA's Director's Prize in 1936.

By 1936 there were some really clever people around, some kids who could draw like bloody angels. Alex Galt was absolutely amazing. He could out-Orpen Orpen. Galt and Crosbie were proper students – they were really good. Bill Hutchison took the three of us into the Glasgow Art Club. At that time, and Bill knew it, the club was your best hope of acceptance as a painter. It was very Edwardian, lush and respectable – a haven of middle-class Glasgow. You didn't dare go into the dining-room with your coat on. There was a card room. There was everything – including all the big collectors with money to spend. Now it's largely occupied by the working classes. Bill wanted us to see and enjoy the place, and also to bridge the generation gap. We were in our early twenties; most of the members had come through the First War and were over forty-five. The only thing I can say about the painters among them is that they were a better class of rotten painters than the working-class, tuppence ha'penny art school people we have now. I have a great contempt for the 'trained' art school painter.

We were particularly lucky at GSA. The director and head of the painting school had their own personal and beautiful Mackintosh studios. Hutchison would take Bill Crosbie and me to his studio to paint from life. He had that kind of generosity, an airy, relaxed confidence; things just happened for him. Scots can't cope with success. But he was an Anglo-Scot, officer class, with the grand manner we came to know from Harold Macmillan.

I heard him once, after dinner, speaking to his own kind in Glasgow Art Club. His subject was Paul Cézanne and he was talking the most idiotic rubbish. They thought it was wonderful. Later in my life I was waiting for him at Dover Street Art Club in London – he'd paid for my being there, by the way. I had said I was waiting for Sir William. 'Oh, do come in!' And when he came in eventually, the whole lot of them stood up. He was an extraordinary man.

Donaldson's curious extra-mural attachment to the school of art seemed to come to an end in 1937 when Hutchison awarded him the Haldane travelling scholarship – a coveted prize. He went abroad for the first time in his life, visited Paris and Florence, and at the Louvre, the Uffizi and Pitti Palace consummated a love affair with many of the masters.

The trip to Italy was salutary. I think of Florence in 1937 as my first and last great exhibition of art. I don't go to exhibitions, really. There's the Royal Scottish Academy annual show, a sort of ludo board with coloured things around, but you've got to understand the difference. This was 1937 and the Uffizi. And this little Lanarkshire boy had heard somebody in the school of art talking about Giotto and all the rest of them. I hadn't realised, for a start, that Giotto was Italian. The only Italians I knew were chip shop people – fine for their vinegar and chips, but weren't they dirty? That, then, was how they were regarded.

When Bill Hutchison granted me the fifty-pound scholarship it rocked the boat. I'd never had fifty pounds – an enormous sum. So I'd go to Italy. Imagine it, I was twenty, on a train from Central Station to London, then across the Channel and everything done slowly. I arrived in Paris eventually and you could feel the ominous feeling of oncoming doom. I was wise enough, I think, to realise that the fat man in the café who served me onion soup was terrified of a repeat of Verdun. You could feel it in the air. Then on, winding through France by train to the Italy of Mussolini who, we had been told, was another ice-cream vendor. Eventually – Florence. It was a bit different from Hamilton. Bewilderment heaped upon bewilderment. For the first time I saw the remnants of the Renaissance and, oh Christ, I was embarrassed and confused. I didn't draw, or any rubbish like that. After breakfast I just walked day after day to the Uffizi and wondered. I had the place to myself. I remember one morning being very upset because some other bugger got there before me. And, of course, the whole substance of art was made manifest to me and it remains the only experience that really matters to me as a painter.

Mussolini's *fascisti* were jumping about in black shirts with daggers and jackboots. Most of the grand Italian families seemed to be represented by homosexuals. Dante's Florence was still magical. I didn't know it at the time, but there were people from Texas there writing novels in the land of Giotto. So many people were wealthy, tragically wealthy. Florence at that time was a

18. Garden, Alassio, 1959

quiet place. I don't remember a motor car. And there they were, the great Botticellis and the Da Vincis spread out for me – the whole masterplan in front of my eyes. I could never forget it.

I didn't bother to see all the other beauties of Florence. The book had been opened for me at just the right place. It would be truthful to say that it was crucial. Of course, the experience left me with a dichotomy: do I prefer Giotto, for instance, to Rembrandt? Intellectually I understand the difference, but I'm still left with a dilemma. A huge experience like Florence can leave you mindless. If you look into yourself you arrive at the conclusion that everything worth doing has been done, and you can drown. Current art school teaching, so book-based, will tell you that so-and-so ate his mince at twelve o'clock every day, but it doesn't do much for somebody trying to paint something. You shouldn't have to make a choice between Giotto and Rembrandt. You should learn why they were both magnificent painters, and that who is better than whom is irrelevant. You have to learn, too, to live with the magnificent dead, and if you don't even try to be like them you might as well become a coalman or a person in the school of art.

When Donaldson returned to Glasgow another study year awaited him – the equivalent of a post-graduate year award to outstanding diplomatists. As Neville Chamberlain parleyed with Hitler and promised 'peace in our time', Hutchison offered his protégé five shillings an hour to teach classes in the night-school.

The Empire Exhibition of 1938 was staged in Glasgow's Bellahouston Park. It was a spectacular event, curiously submerged nowadays in the city's social history, and would probably have ranked alongside many of the century's landmark expositions if it had not been overshadowed by the threat of imminent war. I remember being taken to it – my first visit to Glasgow at the age of ten – and to this day its ambience and architecture merge in my mind with Korda's classic version of *Things to Come*, the first film I saw in a cinema.

The 'bright boys' of Scotland's schools of art were employed to decorate pavilions, several visionary buildings erected under Thomas Tait's Empire Tower. Donaldson painted a mural – 'an innocent, simple thing, using what we called

distemper in those days' – and remembers Hugh Crawford, Bill Crosbie and Walter Pritchard in the Glasgow team, and John Maxwell, then at the height of his Chagall period, and William Gear from Edinburgh. The huge scale of murals and pieces of sculpture was in itself a challenge – 'I think the aesthetic quality of the work was highly questionable' – but at twenty-two he found it a lot of fun.

The Empire Exhibition, 1938

> Walter Pritchard decorated this thing – medieval Germanic persons with big breasts – but the great contribution was a decorative panel by Johnny Maxwell. It was delightfully controlled naivety, and caused all kinds of hellish jumping up and down. Johnny Maxwell is one of the few east coast painters I've had any time for. But there was all manner of madness.
>
> The most tragic story of that exhibition concerned Archie Dawson, the last of the great Scottish sculptors. He had been appointed to make a sculpture of Saint Andrew. It was made in the school on the most beautiful armature, a huge thing, with its base all shored-up to take the weight. After months of work, and on the night the statue was erected, Archie died. He was loved by so many people. He'd been a sniper in the First World War at the age of 16. He was a superb craftsman and a super guy. Never talked about art at all. Just did it.

Regrettably, nothing much more than sketches survived the demolition of the Empire Exhibition. By that time air-raid shelters were being built in public parks and private gardens, and old and young were being taught how to save their lives with a gas-mask.

The declaration of war in 1939 put the existence of GSA in great hazard. The national emergency, the conscription of able-bodied young men, the fear of bombing raids – with Glasgow regarded as a prime Luftwaffe target – convinced the authorities that the school should close down. 'Bill Hutchison saved us. Oh, he did this, that and the other. I don't know how he managed it, but he did.'

The diminutive Davie, like everybody else of his age, was summoned for a medical examination which would determine his grade of fitness for war service.

> I dutifully peed in the bottle and a nice old medic whispered over the wall to his mate. I heard him hiss, 'You can't put that man in a trench.' I was pleased about that. All I saw was a bloody big German with a bayonet. They made me

grade 3. I was looking for grade 10, because as things got rougher in the war they were even calling up wee sods like me.

From his early childhood and until the age of sixty-five, Donaldson suffered from regular and intense migraine. About five days out of seven he would have severe headaches. They still occur, but less frequently. He never did discover why, apart from his lack of height, the wartime doctors graded him unfit.

During what became known as 'the phoney war', Donaldson continued to instruct his night-school classes, but as staff went off to serve in the forces he graduated to teaching first- and second-year students 'in a very junior capacity'. It would be 1944 before he was appointed a full-time lecturer, a member of staff with a permanent kennel in what he called 'a home for lost dogs'. But in a beleaguered Britain, with Nazi invasion still threatened, he felt he was on his way.

<center>❊ ❊ ❊</center>

W.O. Hutchison's flamboyant personality, and his kindness to Donaldson, did not blind the young man to his patron's deficiencies – to his social-climbing, posturing and, when it came down to it, his abilities as a painter.

> There was a love-hate relationship between Hugh Crawford and Hutchison. Hugh was a brilliant teacher, and he knew – and I knew – that W.O. Hutchison was an idiot as a painter. He was not one of us, but by God he could outmanoeuvre us any day.

Donaldson could wear out an evening with his tales of Hutchison. None is more typical of the man and his times than 'his brilliant decision' – as a morale-boosting gesture to the war effort – to present the Royal Navy with a picture of the victory at the Battle of Camperdown in 1789.

> And this was 1941. The significance of W.O.'s offer is not clear until you realise that Admiral Duncan was the last Scotsman to command the British fleet in battle. W.O. showed me a sketch, and it was like a schoolboy's romance of what great ships of the line did to each other in war. He offered me five pounds a week – unheard of, wonderful! – would I help him to paint the thing?
> He ordered up a canvas 20' × 18', and commandeered a huge studio, and

I began to square-off Bill's sketch. I soon realised that the proportions of his men-o'-war were ludicrous. I spent hours, a quarter-of-an-inch at a time, days on end, drawing these ships to the proper scale.

Quite clearly W.O. saw himself as Rubens – he looked like Rubens. And the battle raged before our eyes. Masts were shot away, there were people drowning, and he got carried away. Then he started to play the great portrait painter, putting in people hanging from masts, others engulfed by waves.

He'd say 'Look at that, David, isn't that marvellous?' There was a huge knot on the canvas. He painted over it, put a touch of highlight on a little shadow. It was the most convincing big drop of water you've ever seen. He really attacked it when a big turbulent sea was needed.

It was not a very exciting picture at the end of the day, but I learnt a lot from him. Then came Bill's stroke of genius. He invited the High Command to a reception. Never seen anything like it. Renfrew Street filled with cars carrying heavy medals and swords and the best-looking Wrens in the business. Tea and salmon sandwiches up in the studio and Bill running the show, admirals and all. I had painted all that rigging and I said to a rear-admiral that I hoped it was correct. He said, 'I don't know what these strings are supposed to do. I don't give a bugger. I'm in submarines.'

Look up on the mantelpiece, Gordon. There should be a wee box. It was given to me, a little silver matchbox, commemorating the painting.

GS *It says 'Camperdown. David A. Donaldson. The Royal Navy and Royal Marine Canteen, Rosyth, 1941.' Is the painting still there?*

DD I think it was taken down, mercifully.

GS *By Royal Navy appointment, David Abercrombie Donaldson. That's not bad, is it, for a wee bastard bairned up a close in Coatbridge?*

DD Beautifully put.

Somehow it seems necessary to remind ourselves of a gulf of years. Not even half of the tumultuous twentieth century had passed. In 1942 the Japanese captured Singapore. Montgomery's men won the battle of El Alamein. Hitler's gas chambers began the Holocaust in earnest. In America, Bing Crosby dreamed of a White Christmas for the first time, and Vera Lynn sang optimistically about bluebirds returning to the white cliffs of Dover. By coincidence, in occupied

France, Bonnard painted *L'Oiseau bleu* and Braque put the finishing touches to the canvas he called *Patience*.

Donaldson is deeply conscious of the chasm of time. 'It was so very long ago. A totally different world.' And he realises that he inhabited two very different worlds – the school of art, an enclosed and rarefied community, and the world outside, Greater Glasgow at war, a teeming stramash of heavy industry and naval targets waiting to be bombed.

19. Sonata, 1988

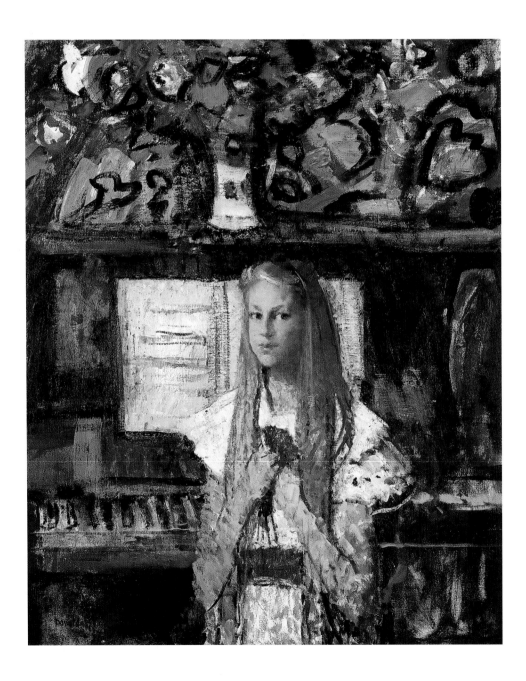

Even before 1939, GSA maintained a curious independence. It did not 'deal', as Donaldson puts it, with universities. Nor did it conform to any of the current social patterns. He remembers how its student society was conscious of the reality of the oncoming war, but remained aloof and got on with its business. It cultivated its uniqueness. 'If you weren't at the school of art, you weren't anybody.'

Donaldson had won the important Guthrie Award at the Royal Scottish Academy's 1941 annual exhibition. He rented a studio near the school for twenty pounds a year. In 1942 he married Kathleen Boyd Maxwell.

She was a very beautiful girl. Her mother was also extremely beautiful. Kate – in certain senses and within her capacity – is one of the most literary persons I've known. She had come from a literary family and was, and still remains, totally outside society. I'm remembering a period piece, really. She'd grown up in an intellectual leftish tradition against the fascist angst in Germany and in which Soviet Russia could do no wrong. Her parents were very much involved.

Anyway, we co-joined – to use a delicate phrase. It was really *la vie bohème*. We camped together long before anyone heard of shell suits. Then we got married. Not long ago I wrote to my son from France. I said: 'I want to assure you, David, that your fertilisation was one of the best things that happened in the world.' It took place at Killearn, in a caravan.

We lived in my studio in Renfrew Street, which was also a venue for one or two strange and drunk people. Quasi-intellectuals, interested in literature and painting, getting drunk every night, and all that cairry-on. We lived in penury, but Kate would agree it was an interesting penury.

I had solved a big problem – the loneliness of being an artist. It was a kind of urban desert-island situation. We isolated ourselves as a species of persons. Nobody talked about making a living. So we lived happily with the rain coming through the studio roof. When David Lennox Donaldson was born, the nappies that folk used in those days were frozen every morning.

After forty years of estrangement the actress Katie Gardner – as she is now known – has come to live near David in western Glasgow. 'She doesn't like smelly cheese,' he announces – apropos of nothing at all, although it might have had something to do with the fact that, to help her out, he fetches her groceries from the supermarket. She was a guest at his seventy-ninth birthday party, and

in telephone chats keeps reminding him 'in her funny smoky voice' of events in their young lives that he cannot remember. 'She's obviously got some other method of recall, or maybe a need for memories.'

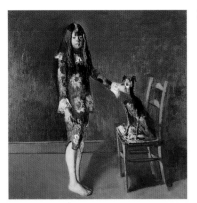

20. Caroline with Dog, 1960

We divorced, I suppose, because the party had to stop, to end the sheer lunacy of our life, even if it was rather romantic and beautiful. Being a person of sort of low intellect I thought you ought to have a decent house and a cooker. Kate had never cooked anything in her life. I arranged a wee camping kitchen in the studio – where I officiated, because Kate knew nothing about food. We didn't quarrel in the accepted sense, but at twenty-five there were so many other directions one's mind was travelling in. Then when David was born, I didn't realise that for her it was such a big event – as most men don't. The pressure became unbearable. A dragon had entered the studio. Our beautiful world, the Sitwell-like debates came to an end. The making of spaghetti for the starving intellectuals ceased almost immediately. We were in no sense ready for what had come into our lives.

I suppose I was looking for what I had always sought. I had been brought up with a 'mother' who cooked the dinner and washed the clothes. Our marriage wasn't like that at all. I can't remember them, but there must have been painful interludes when the harsh reality of the world pressed in on us.

Our separate interests pulled us apart. Her love of literature, which was profound and still is, attracted her towards the emerging Unity Theatre, and that really buggered it up. In total fairness, she found with these wordy people a much more interesting way of life than the one I could offer her. I was only a confusion of another kind.

David was a serious problem. I had no back-up from my family. I didn't know what the hell I was doing. Kate was running about the theatre, and my feelings about being separated from my own mother convinced me that David should stay with Kate. That created terrible problems. By the time he was about three I paid for David to go to a residential school. I know people thought I was putting the boy out into the cold world, but I believe I had no alternative. I learned a lot from Kate. It's difficult to say what I learned because she's so bookish. Where she lives now she's swamped by books. She's lived a hell of a life. An extraordinary girl. Still so very beautiful today.

Looking back, it was what the world calls a nervous breakdown. Again the world was cruel and cold . . . And then I met Marysia . . .

THE TEACHING OF ART

In all our conversations Donaldson has protested that throughout his years of 'hanging about' at the school of art he had no idea what he was supposed to be doing. Today I get off on the wrong foot. I assume that he approached the role of teacher with similar uncertainty. 'No. I'm sorry, I must have given you the wrong impression. This was one of the few times when I did know what I was doing.' His remit was to teach drawing to the youngest students as a very junior member of part-time staff under the formidable Henry Alison, a fine draughtsman who had been trained at the Slade – 'a right old bastard'.

He was shot to buggery at the Somme or some battle during the First World War. He had lost one eye and cried with the other one. He spoke with a dreadful east coast accent, saying 'No, that's no' right, no, it's no' right at a'.' That was his contribution to the intellectual culture of Glasgow. He had a rough simplicity of thought, but he seemed to adore twisting people's minds. Girls were found crying in corridors because he tortured the life out of them. I stood in terror of this fanatical sergeant-major. He adored the Germans because their surgeons had managed to save his sightless eye as an organ. When the Second World War came he thought we were on the wrong side. He wanted to fight the French. Until the day he surrendered his life to the Lord God Almighty he copied himself on his idea of Prussian officers. He was a Junker. His hair was *en brosse*. He wore a Norfolk jacket and neat breeks.

Alison was head of the under school – the first two student years. Bill Hutchison appointed me to work with him. Although I seem to be laughing at him, I'm not really. He was a person. He mattered a lot and he insisted on discipline, which is no bad thing. I had no facility for life-drawing but if you consider drawing in the formative stage as a learning process, as the anatomy and mechanics of the human body, of course I understood what it meant. I couldn't do it, no. But then I was very persuasive with other people. In

Glasgow drawing was holy writ. There was no talk of aesthetics, none of the semi-amateurish psychiatry which modern art schools have doused themselves with. It was purely an engineering process and it stayed with me all the time I was in the school of art – and still does, actually.

For Donaldson the war released energy and opportunity. Ian Fleming and others marched off to the fray, leaving teaching roles for people like himself and the watercolourist John Miller. Studio space became available, the school shrank to thirty or forty students. 'In a sense it was probably the best time in the history of the Glasgow School of Art.'

Students were expected to sleep in the school during fire-watching shifts and earned half-a-crown a time.

21. Drymen Church, c.1976

Henry Alison was in a state of glory. He commanded a quasi-military operation. We were issued with steel hats. A studio was set aside as a dormitory and I was appointed a kind of captain of home guard. It was fucking hilarious. There were soup parties at three in the morning, then the big bonus of kippers for breakfast in the refectory before starting classes. It was a wonderful kind of finishing school, with some of the best art teachers in the whole bloody country. At night Gruppenfuehrer Henry Alison sneaked in to see that the wee paraffin lamps were on the right nail, and God help you if they weren't. Then there was the night of the Blitz and the place full of shrapnel coming through the window. Servicemen home on leave and needing a bed for the night used the school as a howff, rolling in at two in the morning. Great fun.

I'll tell you another reason why it was such a different world. A great friend of mine, Pat MacEvoy, was immensely poor. Pat needed money so badly he fire-watched every night. He ate plain spaghetti, just boiled in water, as his regular meal. He had a room in the place. As Philipson would say, he was a scallywag. During an air-raid Pat decided to get a chair – a Mackintosh chair, as it happened – but he didn't take it because it was a Mackintosh chair, he just needed a chair in his room. Alison nearly went out of his mind. His rage at MacEvoy was the first sign I ever got of a Mackintosh cult. Mackintosh was just another chair to sit on. You could pick them up for peanuts. Mackintosh was the other side of Alison. He had great respect for the tradition of the school and its distinction as a building. For us it was a place to work in – a beautiful place – but we knew bugger-all about it.

The small clutches of wartime students included Joan Eardley, Margot Sandeman, John Cunningham, Danny Ferguson, Cordelia Oliver and Sinclair Thomson. Something close to a ten-to-one student-teacher ratio, with tutors like Crawford, Alison and Fleming (before he went off to the army) working in abundant studio space, heightened the intensity of an atelier system of instruction and response. Hugh Crawford, in his long painting goonie, exercised complete authority. Fleming has never received enough credit for his influence on GSA or the quality of his teaching: 'He just insisted and demonstrated that he could draw better than you.' Donaldson found it difficult to teach under such masters as Crawford and Fleming. 'I have never heard lectures on painting like Hugh's. All the rest are mere infants.'

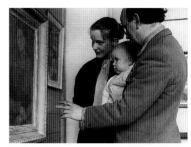

With Marysia and Sally, 1951

Crawford's wife, Kathleen Mann, was head of embroidery and a superb artist in her own field.

You should have seen her when she was young. I met her about a year ago and she still had the girlish charm we saw when she came up from Chelsea. Hard-nosed diploma students had to include embroidery in their course, and suddenly acquired an extraordinary interest in the craft. These were the same wee sods from Shettleston who used to pass lighted fags to monkeys when they were drawing them in the animal room. Our monkeys smoked. But at that time Kathleen used to go about the school with a beautiful pet monkey perched on her shoulder. We had style, boy.

I taught diploma students by sheer chance, because of the war. I was young, not much older than people I was teaching, and I enjoyed it. Most of them were relatively interesting. They could get drunk, but they were bright. I was called Mr Donaldson, but a few became close friends and asked me for fags. Those buggers had all the energy. Everybody who has taught would admit that many times they've looked at student work and thought, 'Oh, I wish to Christ I'd done that.'

There is a story about Titian, the greatest of the Venetian painters, who is believed to have lived until he was ninety-nine then died of the plague. He was held in such awe by 1548 that, so it is said, the Holy Roman Emperor Charles V, the most powerful man in the world, stooped to pick up a brush which Titian

dropped while painting his portrait. Four centuries on, Donaldson venerates the Venetian Master, the painter's painter, who conjured colour, light and air to break the laws of composition and give flesh a spiritual presence.

One of the most beautiful things that ever happened to me was being invited one day to lunch at the National Gallery. I found myself sitting beside Titian's *Diana and Actaeon*, and the Prince of Wales was there.

If anybody wants to learn how to paint, that Titian is the whole bloody works in one. It's miraculous. I'd known the painting since I was a boy and still looked at it with utter amazement. It's not a painting you can pass. It is the very stuff of the visual arts.

I had asked him to think of some favourite paintings by other artists, works that stirred him, inspired him, engaged him in some special way. Paintings he would encourage students to see – paintings great and small – and even those masterpieces which are not necessarily masterpieces just because Gombrich or Kenneth Clark said so.

He is scathing about the way the governance of GSA, from the very beginning, was invested in men whose knowledge and experience, training and discipline, were rooted in an English canon of classical art which ignored the genius of Turner.

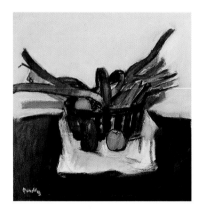

22. Leeks, 1978

I think Turner is probably the greatest painter England has ever had. It's curious that the English never established a school from Turner. Constable, yes – every amateur cushion-painter apes Constable. But Turner, so brilliant they couldn't cope with him. The only person who came near him was that mad Irishman, Francis Bacon. He was a painter. The others are no more than illustrators of *Radio Times*. They don't seem to grasp the traditions of being a painter, don't have the nous to see beyond the fey and whimsical to the wonder of real painting. That's why they fell for so many Tennyson painters, like the pre-Raphaelite boys, and came up to Scotland to tell us how it should be done.

Donaldson has never travelled to Spain and the Prado to see the great master-works of Velazquez and the artist for whom he has probably the greatest admiration, Goya. 'In a way I think I'd be afraid. I'm afraid to go and be taught such severe lessons, made to feel how pitiful my own efforts are.' On the other

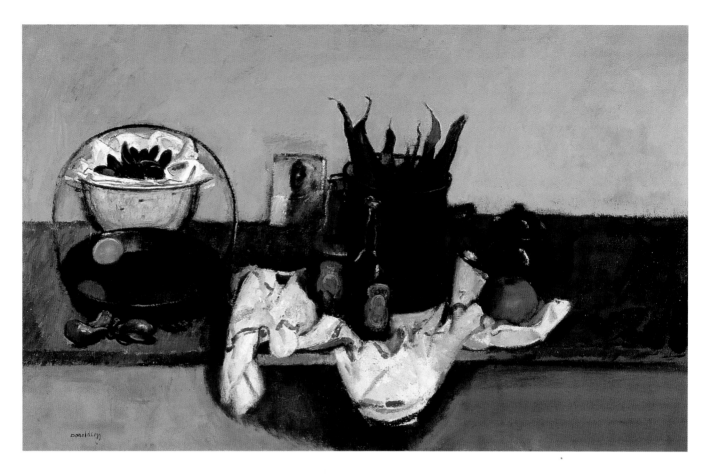

hand, he has never given up trying. 'Most human beings are imitators, they imitate their fathers and grandfathers and, inevitably, like bloody monkeys, learn how to eat a banana.'

One of the glories of Titian's *Diana* is sheer technique. So much of the painting is based on a dull brown canvas. That is the chord which Titian struck – probably above middle C on the piano – so that the whole painting is composed through the colour of the canvas, and brilliantly done. He has constantly confirmed my belief in the technique of painting. There are those painters who are not world figures but have amazing facility for putting what I can only describe as an *attitude* in front of you. We had them in Glasgow . . . Colquhoun and MacBryde, Fleming . . . Forrester Wilson, Crawford . . . That was a funny world I came into.

When I was seventeen or thereabouts I was summoned to Forrester Wilson's studio to be put on the mat he told me how useless I was, how utterly impossible it was for me to continue. He was wee, about five foot tall,

and you could say that I towered above him. The students said he had castors on his feet. But he was a brilliant painter. As he tore into me with a vengeance, behind him there was a portrait he was working on, only three-quarters done, and all I saw was the authority, the superb understanding of his work. I can't find the words to say how affected I was. He was making something beautiful, and I was seeing it unfinished, and saying to myself, 'So that's how it's done.'

That exhibition of Sandy Moffat's we saw in 1995 ['The Continuing Tradition: 75 Years of Painting at Glasgow School of Art 1920 to 1995'] – it was world class, and could have been doubled in quantity. That show owed so much to Forrester Wilson's style and Hugh Crawford's inspired teaching. Crawford – and I would want this to be known – was the forerunner of the great Glasgow tradition.

There were many others, like wee Andrew Law who looked like an insurance agent. They swept into the school dressed like bank managers. None of this sloppy-Joe stuff. They had wonderful style, winged collars and all that, and when you saw them at work, how they set themselves up, they followed rituals which were only understandable if you realised they were trying to paint like Titian. No bloody great pails of anything. Their palettes always polished till they gleamed. You saw how cleverly they arranged the paint on their palettes. There was order and attitude and discipline. I'm trying to paint a composite picture of what art began to mean to me.

LEFT
24. Still-life with Pineapple,
1972

RIGHT
25. Rosie, 1985

By gradually realising what his mentors were trying to achieve, by acknowledging their ability, Donaldson began to respect them and – albeit unwillingly – accept the need for order and discipline. It was the right kind of respect, inspired by example and achievement rather than the diktat of inflexible authority. 'It says in the Bible, by their works shall ye know them.' If they couldn't do it, they were no use to him.

Titian was the core of an early lesson which affected a lifetime's attitude to painting. In those days a student could buy a perfectly prepared white canvas from the school shop for half-a-crown. He was told politely, 'The first thing you must do, Mr Donaldson, is get rid of the white.' A dark grey underpainting, with a 'whiteish' space left to give luminosity where the head might go, was commonplace. He accepts that this was quite sensible 'but they didn't follow it through'. And in his own way, as a solution for himself, Donaldson did.

Above all, Titian was a manipulator of paint. He realised that you can't establish the relationship of the other notes until you strike your middle C – that's when the noise begins. If you in any way darken a white canvas there is only one way to go and that's down. Even if you put pale lemon on it, you darken it. So I decided to reverse the process, go for the light first, then work back from that. What was the point of hitting the high notes, at the very top end of the

LEFT
26. Green and White, 1981–82

RIGHT
27. Still-life with Rosie, 1983

keyboard, if you have deadened their effect by muffling the canvas in advance? Titian's reds and blues and flesh tones sing because they rise above the middle C of the browns and dark ochres of Diana's grotto.

28. Still-life with Red Pot, 1981

In those early teaching days he realised, surrounded by artefacts which represented so much of European culture – antiques, statuary, echoes of the best of Italian, French and Spanish art – he had become more interested in how works of art had been achieved rather than why. It dawned on him that he had been gifted with natural visual intelligence and vivid imagination – characteristics more uncommon in a school of art than you might expect – but his growing apprehension of what the living quality of paint is, and how its application could generate energy and excitement, persuaded him that perhaps he might be able to join those painters who had seen something unique in a subject or had reproduced something unique.

He is quick to admit his 'immense admiration' of the many gifted students who, over half a century, passed through the school. He acknowledges debts to 'one or two people the world doesn't know, who were free with their ideas, and didn't realise the importance of their ideas'. People striking notes on the piano but not hearing or making music – a case of there being none so deaf as those who cannot see.

Back there, you were asking about paintings I admired. There are, of course, a great many, but two in Glasgow which are very special. This one will floor you, I hope. It's a Stuart Park [1862–1933, renowned Victorian flower painter]. Now don't laugh. It's in Kelvingrove – about 12" x 10", just a wee glass with a pansy in it. None of the great noise of battle that Wagner produces. A simple thing, a wee thing by the wayside. It's frozen time, in a way. It breathes.

Then I go back to the Old Master copy I made for the Prix de Rome [of *St Victor with a Donor*]. You don't need art schools. You just need the guts to try to paint one of these things in the Flemish manner, as I did, and in the process learn their whole method of painting. It's simple but good. An oak panel slightly wetted before being roughened up, then the ground laid in gesso and the drawing sketched on like a cushion cover. Utterly simple. They then sealed it and passed over it the natural colours they found in the countryside, various reds and some dark stuff. I learned a salutary lesson about technique. No angst, bugger-all of the kind. The original [also at Kelvingrove] glows like

most European paintings of that period. My sister has my version.

I want to talk about Angus Neil [1924–92]. He's one of the few *painters*, as distinct from *educated artists*, I have known, or can think of – and for me that's the difference between first and second division. He occupied his own private hell. During his time at the school in the early '50s he was decent and polite to me within his ability to be decent and polite. A great many years later I got a strange letter from him. It was to tell me that he was going mad. Not to my credit, I forgot about the matter. It wasn't an appeal or anything like that, but it was a mind in distress. Like everybody else in this world who has had problems, I know that somebody else's distress is never as great as your own.

I've never gone out of my way to know artists. Most of them are a pain in the arse. So I wasn't privy to the gossip about Angus. His letter told me about this frightened guy I'd known. I always realised there was something not normal about him – not art school still-life 'lemon-on-the-table' normal.

I regretted not getting to a posthumous exhibition of his work in Aberdeen, and when I saw the catalogue I was instantly reminded of the exceptional beauty of his still-lifes. The catalogue cover is a painting of roses – just that. It sustains a magnificent idea. You might say this is Burnsian, like *To a Mouse*, the very singularity and nakedness of the idea, and here was somebody who didn't require the cutlery, the checked tablecloth and all the old piss that still constitutes still-life painting. He really knew about these absolutely beautiful roses. It's one of the few paintings that stay with me.

People don't understand about still-life. Come to that, very few understand painting, but still-life requires a different set of values which so many don't have. Nice and decent people think that drawing is something definitive. The jug has lines on it and wee marks on it and decorative curves. But if it's not part of a concept it isn't anything. What's the jug doing there in the first place? The kind of still-life I'm talking about is a concept, something that sets off a trail of circumstances in one's mind, of associations, of ideas and colours. And not localised. All of these things become part of an idea. Paul Cézanne comes immediately to mind, but there are others, like Chardin, who could do this and hold it together as if, in a modern sense, it was in a television frame, singular, something you've never seen before, a vision. Art without vision isn't anything. When it's the real thing it should engage and absorb and even thrill you. I've always thought of still-lifes as the mathematics of painting, as Bach is to the mathematics of music. They must have structure and follow

29. Caroline on Rollerskates, c.1975

the rules and aim for sheer quality of execution. A kind of exercise? Absolutely, always, and to this day.

It was with some temerity that I asked the man who is proud to call himself a painter, who reserves some of his most specific asperity for artists, what place artists should occupy in society.

I've always wondered why people expect artists to have special intellectual powers to reveal to people things they ought to know already, or maybe improve the lot of mankind. I find it extremely difficult to accept that artists are especially perceptive and have powers beyond the normal. Great artists, at the height of their powers, have opened doors for me, offered visions of specialised beauty.

My ideas about art have something to do with a man we called Wee Geordie in Coatbridge. He had bandy legs. I confuse Goya and Titian and Tintoretto with this wee bugger who used to paint our kitchen yellow ochre. And a big pail of yellow ochre in those days was hand-wrought – he made the paint with raw pigment and linseed oil. Geordie would come to us, usually on a washing-day Monday morning, and I mention this because I don't think the great painters were far away from that kind of domestic normality. Wee Geordie wore his wee white dungaree things, and sloshed about in his diarrhoea-coloured pail, and the whole kitchen, the whole day, was sanctified by the smell of linseed oil. This was the work of a painter. I've never forgotten him. I'd be only four or five. He did the job for five shillings, and I don't see much difference between Geordie and the bottegas of Florence. Quite clearly there was a difference – as any art school teacher would confirm; they're very good at telling you things that are of no consequence. But Wee Geordie transformed our world, made it anew. I think he would have had great difficulty painting the things Goya painted. He wasn't trying to tell us anything. If he had tried harder he might have painted a wee person on the kitchen walls, but it wouldn't have told me the things that Titian told me. But the impact, the transformation, was very powerful. He worked his own magic, created surprise, and in that way he was the same as the rest of us trying to paint pictures – an artist in society.

There's nothing more daunting for a painter than the history of art. Take the great fresco tradition from southern Italy. Look what you're up against – the method all pre-arranged and conditioned. How marvellous it must have

been to have a Pope person who knew all the answers and everybody agreed. You work in the simple but complicated way of adding plaster to a wall and painting into it. It was entirely like Wee Geordie coming to paint our house – home-spun painting in a fantastically fine way. None of it was spontaneous. You couldn't paint the Sistine Chapel without an immense amount of preparation. When you got up that high on the scaffold you weren't going to come all the way down for a pee or to eat your lunchtime piece.

Then up near the Alps and towards Venice, in the darker north, the clouds of Protestant doubt gathered, and impulsive painters, men of humour and mood, saw things differently. Suddenly you're in Antwerp or Amsterdam and thinking people, especially painters, begin listening to Luther and asking questions. Audacious people began to think they had the personal right to address the Lord God Almighty.

By the time the so-called Age of Reason arrived, and all the personalised questions about Jesus rising from the dead had been answered, painting had moved a long way from the Renaissance frescoes. It became quasi-political, humanist, just about everything. It was when the French escaped into *pointillisme* that I came in. First Luther, then Freud, then the painting cult of personality, and the beginning of the modern movement.

That's Davie Donaldson's wee book on the history of painting. I'm not an authority on anything. I'm as lost as ever. The only thing that redeems my attitude is the memory of Wee Geordie, not because he came from Coatbridge, but because he was a wonder merchant.

I don't like the term 'Scottish painting'. It always represents to me that solemn educated-person skating [Sir Henry Raeburn's *The Reverend Robert Walker Skating on Duddingston Loch*]. A self-righteous, tight-faced, miserable bastard. Have you ever noticed, by the way, on his hat there's the outline of another hat? It's one of the technical adjustments Raeburn made and the original paint shines through. I've never known anybody who looks more like Protestantism at its worst, yet it's a beautiful picture.

30. Christine, 1993

31. Isaac Sclar, 1966–67

PORTRAITURE

The progress of art, like the evolution of human achievement, often succeeds by standing still for a moment and reconsidering the past. Primitive man fashioned imaginary likenesses of his gods and actual portraits of his fellows in stone and clay. Renaissance man flattered the princes of his day and retold the chronicle of Christianity in tempera. Van Eyck more or less invented the process of oil-painting as we know it in order to heighten the realism of his portraiture. It is not surprising that, on his most famous picture, *The Betrothal of the Arnolfini*, painted in 1434, he placed his signature in such an obvious position and in such an unusual fashion – in Latin it says 'Jan van Eyck was here'. He wanted his portrait of the bride and groom to be a witnessed account, a faithful record of how he had seen them on their wedding day.

When, two hundred years later, Velazquez painted Pope Innocent X with such a dramatic sense of that man – alive and breathing, challenging us with his gaze – the Spanish master felt no need to tell us he had been in the actual presence of the Holy Father.

Three hundred years after that David Donaldson, deeply influenced by the masters, approached each portrait as a unique personal challenge. He knew the public would judge his work by the nearness he had got to a 'living likeness', but in the act of creation that criterion always ended up taking second place to his need to make paint speak of and reveal his expressionist response to a dramatic human experience.

I asked him if he could remember his first portrait.

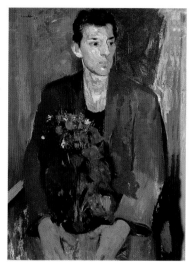

32. Portrait of a Young Man –
Alf Avella, 1948

It was of a young girl. Subsequently I found out she was my sister. She still has it. I must have been about fourteen or fifteen. I wish I could paint like that now. It's rather a nice thing – jejeune, pre-Kokoschka, about whom I knew nothing at all. A wee naked girl of about seven, badly drawn, but it has some quality. It's years since I've seen it. A Northern Irish minister – you might think of him as

St John crying in the wilderness – used to come and see my grandmother and talk about things unknown to ordinary people. She told him I was upstairs painting. She was very proud of me, poor old soul, and hoped I would be converted. I was working on this picture when the minister came into the parlour. It was full of my painting stuff and a Victorian piano, with a view from the window that would frighten the dead. 'What are you doing?' he asked in his Reverend Ian Paisley voice. I turned the easel towards him. 'Oh, I don't like pictures with no clothes on.' It was that Northern Ireland boom of doom. I don't know what the hell he was doing in Coatbridge.

There were other early things. I entered the professional world, if you like, in my third year at art school. A dentist asked me to paint his two daughters. I got in a hell of a mess painting these two girls – separate portraits, different positions. One was ice-cold in the manner of a broken-down Botticelli. The other was not in any tradition that I remember. The dentist was well-off. He could afford the twenty pounds. Within the last ten years I saw one of the portraits again. It was no worse than a lot of other people's portraits.

The interesting thing is that even then, at seventeen or eighteen, I was avoiding the commercial reality of conventional portraiture. I wanted no connection with that kind of painting.

GS *Have you any idea how you acquired that attitude at such an early age?*

DD I'll have to try to be as precise as I can about this . . . I suppose portraiture was an attempt to connect with other people. Maybe that is at the heart of all human existence. I often think of those Easter Island figures, those mysterious heads in the South Seas. I thought of my cats – when they caught rabbits they always ate the head. Primitive man beheaded his enemy because the head was the fountain of knowledge, the source of his being. And maybe in a sense, I think of the head of a person in a similar but less bloodthirsty and more constructive way. The human head has always fascinated me. As a boy I made tiny wee carvings out of blackboard chalk. They looked bloody dreadful, but they were heads.

One of the loneliest things in the world, as you well know, is to take a blank sheet of paper and wonder about infinity and what life is all about. The same is true of an empty canvas. I found that portraiture filled my day with a person. It didn't matter very much which person, it gave me a purpose. I remember my wee studio in Renfrew Street, coming in from Coatbridge every day – to be a painter. The whole thing was mad. If I was to be a painter

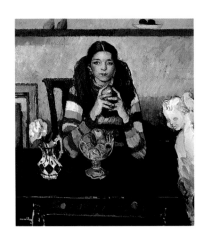

33. Bunches, 1980

I had to do something. There was nobody there and it was cold and miserable, so I did things called still-lifes, which bored you to tears in ten minutes. I realised that portraits were talking still-lifes. They became a solution to loneliness.

GS *You must have known that the success of a portrait depended on its likeness to the subject.*

DD Absolutely. That was the nub.

GS *Even then, before you had the confidence to make a case for your own view of portraiture, were you trying to create a likeness?*

DD In every case my sheer will was directed at making it look like Auntie Jenny or Uncle John. This never varied throughout my career. But therein lay a great difficulty because, as you well know, the noun (the likeness) requires the adjective (some spiritual dimension) to be *lifelike*.

I had learned, or was pursuing the idea, that the sheer sensibility of painting was there to express Uncle John. It's been my experience that very few people understand this. It is the language of painting. I would be delighted if people said, look at that, you can see Uncle John's moustache twitching. Of course a likeness is important, but I was – and remain – uptight about the language and grammar of painting.

It saddens me that so many people have been happy to accept tenth-rate photographic rubbish as portraiture. It's rubbish because there has been no attempt to use an art form.

I have a studio in London, in Chelsea, and the idea some years ago was that I would become a Chelsea portrait painter. I was pathetic. The portraits cost a lot of money and made a lot of people – including my wife, Marysia – unhappy. I wasn't cut out for that scene. Making it look like Uncle John is first principle. Any other principle doesn't matter. If you can't get the nose right, you can't get anything right.

GS *Have you been embarrassed by people who have paid for portraits not liking the result?*

DD There was one beautiful portrait, at least I thought so. Two years later I asked if I could borrow it for some purpose and I got it back unwrapped. It had spent its time under a bed. The wife person who commissioned it had peed herself, I think, when she saw it. There was nothing harsh or outrageously modern about it, it was just my attempt to use painting language perfectly. I was hurt, but that often happens.

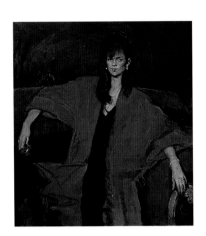

34. Emma in Red, 1985

GS *How do you differentiate between good and bad, whether a portrait has worked or not?*

DD It's very difficult. It's a risky business. You've been put into another dimension. After the heat dies down you realise each experience has been unique. I was always grateful when my sitter left. I'd spent two or three hours at the battlefront, as it were. My head was still ringing with the noise of battle when the car came to take them away. There was fear and trembling and colossal anxiety. Sometimes I'd get a phone call an hour before they were due to arrive, to say the sitting was postponed. I felt wonderful. Maybe he's broken his leg and won't come back. I liked them and disliked them at one and the same time. They represented fear for me. The fear that says 'as sure as Christ I'll not get it right'.

I used to teach – and still believe – that everything is paintable. There was one wee man, I'd agreed to paint him but I had never seen him until he arrived at my studio. My professional decent self said, 'Good morning, how are you?' My other self said, 'For God's sake, this is not funny.' I sought the solution in an old family story. A new-born child was described by somebody as 'an awfy ugly wee wean'. And my granny said, 'How dare you say that about one of God's creatures.' This man looked like a beetle. He wore a modestly tailored suit in a beautiful grey and it seemed to say everything about him as a person. The jacket crept right up round his head. He seemed made of the same stuff. He looked like a slater, those crawly things you find under stones. My mounting horror and the first sitting were awful. However, the next time he came I asked him about dyes – he was quite big in the rag trade – and this carapace of a suit suddenly sprang into some semblance of life. I've always been interested in colour and its origins and there we were, relating to each other in an interesting way. The wrinkled grey suit became a man.

GS *How did you react to offers of boardroom commissions, town councils asking you to paint the provost, and all that trade?*

DD There are one or two of these public commissions, a few, which are among the best work I've done. Of course I made the mistake of thinking that people are concerned about painting. An incredible number know nothing, don't look, don't see, and make no attempt to find out. I always tried to paint as beautifully as possible, to make my grammar immaculate. The nouns and adjectives which other people have in their heads about my subjects are unknown to me. When I look at these portraits again, I can see what I tried to

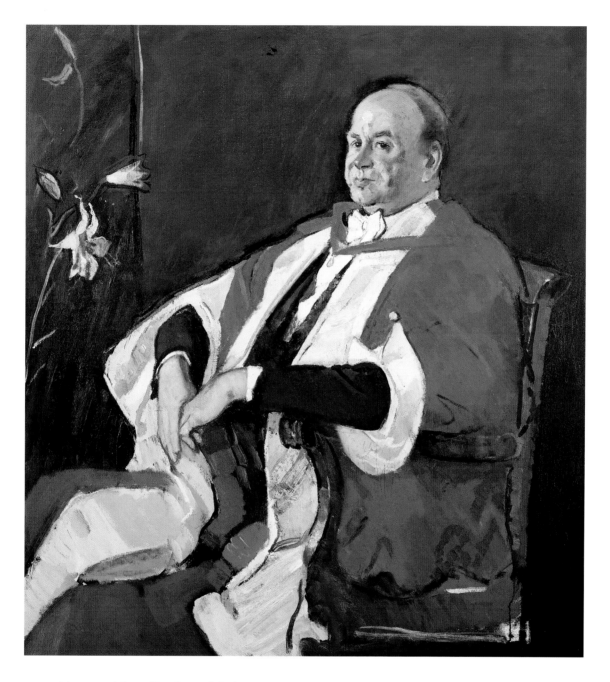

achieve, and I'm still quite satisfied that my approach was right.

GS *Where do you see yourself in the pecking-order of portrait painters?*

DD It has always puzzled me why people paint so badly. It's beyond my belief that they could be so inept. I assume that if people want to paint they want to paint like Goya. That's arrogant, I know. I've never painted as well as Goya, but it has been an aspiration. I had to try. It's been a fact of life. Of course, by the time you're facing the canvas you're in the quagmire of your own mind,

35. Professor Sir Graham Hills, 1991

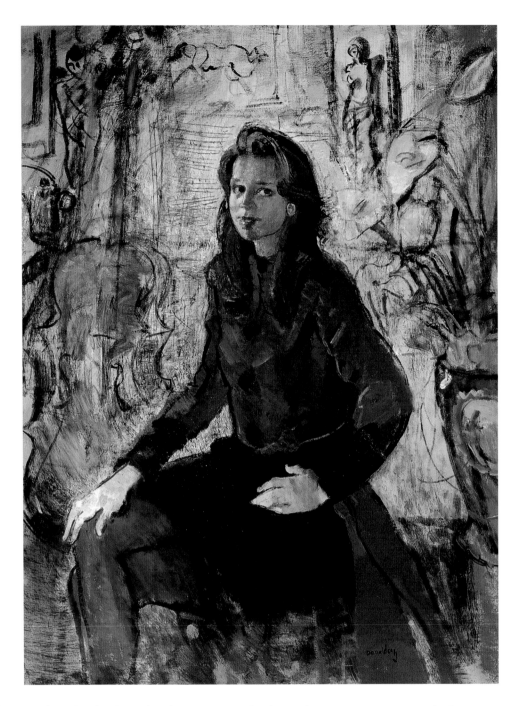

36. Alexandra, 1989

hopelessly drowning in your own inadequacies as so many people have successfully drowned themselves.

Men are difficult enough, but most women I've painted have been rather splendid, and presented a kind of . . . well, it's not a difficulty, it's almost a requirement . . . You have to paint from beneath your navel. Perhaps it's the best compliment you can pay to any woman.

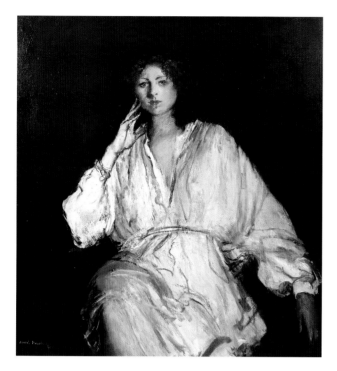
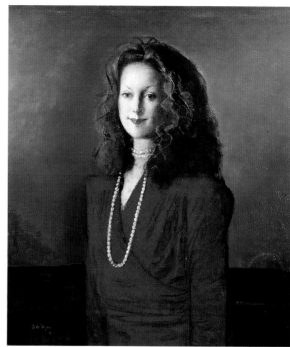

GS *You're still being serious, are you?*

DD Oh, yeah.

GS *You're saying that there has to be some kind of erotic transmission – at the very least a frisson of something?*

DD Oh yes, I make no bones about it – I think an erotic content in paintings is great. Erotic, in contemporary language, means randy, and I think there's no harm in it, and you're talking to somebody who's nearly 80 who's become a randy old goat. I'm only sorry I didn't make more of it when I had the chance. What a waste of time all this painting business has been. I mean, it would have been far better if I'd just put my leg over and been done with it – in a most wonderful sense. But the strictures of the Scottish Baptist Church, all that indoctrination, puts a grid of iron between you and reality, so you fantasize your desires and paint them. It's an interesting thought. Supposing the grid had been taken down; I probably wouldn't have painted at all.

When I was taken into the Donaldson family at Coatbridge I cuddled up in bed at night alongside a girl who was my auntie, my father's sister. She was sixteen. I was about six or seven. There's so much said these days about child abuse – I thought it was wonderful.

But of course guilt grew out of the 'thou shalt not touch' stricture. Those seeds were sown swiftly in the kind of community I was in, and 'thou shalt not

LEFT
37. Annette in White, 1977

RIGHT
38. Gay Grossart, 1963

touch' came to mean that if you were painting somebody you kept your hands covered with paint. I had painted some of the most beautiful girls, really gorgeous, and painted them gorgeously. I suppose if I tried anything else I'd never have painted them, and I admit I get jumping mad about that.

My auntie and I slept in a hole-in-the-wall bed in the kitchen. There was always a bright fire in the grate and we could see it through the curtains. What more could a wean want? It was a happy time. To be perfectly truthful, I don't know if that was my introduction to sex. It must have lasted for two or three years. I just remember it as warm and cuddly.

Donaldson seldom knew or saw in advance the subjects of commissioned portraits. Perhaps he had met them socially or knew the faces they offered to the public, but his appraisal of them began only when they presented themselves in his studio. I suggested that after he had learned what he could achieve with paint some kind of aesthetic abandon sparked off the creative process.

DD I'm not so sure about that . . .

GS *There's a person in front of you and you've been commissioned to paint their portrait. A small drama has been set up – a subject, a setting and a blank canvas – a totally unnatural situation.*

DD I agree entirely.

GS *And you add your own degree of apprehension to their nervousness. They sit and think and wonder what the hell you're doing to their vision of themselves. You are in complete command. You have to fulfil what you call the Uncle John obligation, and at the same time respond to the dramatic challenge. Curiosity is compounded with nervousness. You have to accept the Uncle bit, but in the process you are overtaken, charged up, by the dramatic tension.*

DD Yes, I'll buy that. It's like a disease. You're trailing your guts all over the place.

GS *And there's no preliminary sketching? You go straight in with the brush and paint from the start?*

DD It's the only thing I can do.

GS *You received them with no preconceived notions about character, personality, who or what they were?*

DD That is what I was trained to do.

GS *You brought no psychological curiosity to the task?*

DD I had no authority to do that. This is a lumpen idea but it's rife. People think you've analysed the person. I really don't know what a person is. I make no attempt to know. What happens when the light strikes a person is purely my physical understanding of what's in front of me.

GS *A photographer might say the same – his lens and emulsion catch only light where it falls.*

DD Yes, I agree.

GS *Of course the photographer can manipulate light, throw things out of focus, dramatise. Are you creating similar effects with paint?*

DD No, I don't accept that.

GS *So we come to the mystery. You've greeted the subject without prejudice or preconception. You paint them, as you say, as the light falls on them. Yet a good portrait often reveals character traits which people who know the subject intimately have always suspected but never seen for themselves. You've caught some essential part of their person.*

DD I can't accept the 'caught' bit.

GS *Well how does it end up on your canvas?*

DD That is factor 'x'. I have certainly never claimed such a distinction for myself. I try to be a good painter.

GS *Tell me if I'm wrong in paraphrasing you. As an artist you see it almost as a duty to achieve a likeness, but through the character and magic of paint you try to bring to the portrait an adjectival description of your subject. Is that fair?*

DD No. Because if that thesis has validity it would require a clear idea of what I was doing. I'm speaking to you as another creative person and ask you to imagine a white horse galloping in a field that has no boundaries. It chases itself all over the bloody place.

A clear example of this is my portrait of Sir Hector Hetherington [Principal of Glasgow University, 1936–61, painted in 1960]. It created a great rumpus. The detractors of Hetherington were delighted – I had revealed the man they despised. People who liked him thought it was terrible (Plate 39).

I made no effort to say anything about Hetherington. He was a nice man, perfectly genuine and pleasant to me. But he was a great Edwardian, a power figure, not only in Glasgow but in the land, and therefore if you represented him faithfully in his countenance and dress, he would seem everything power-ful. I had never before painted such a powerful person, but I felt quite powerful

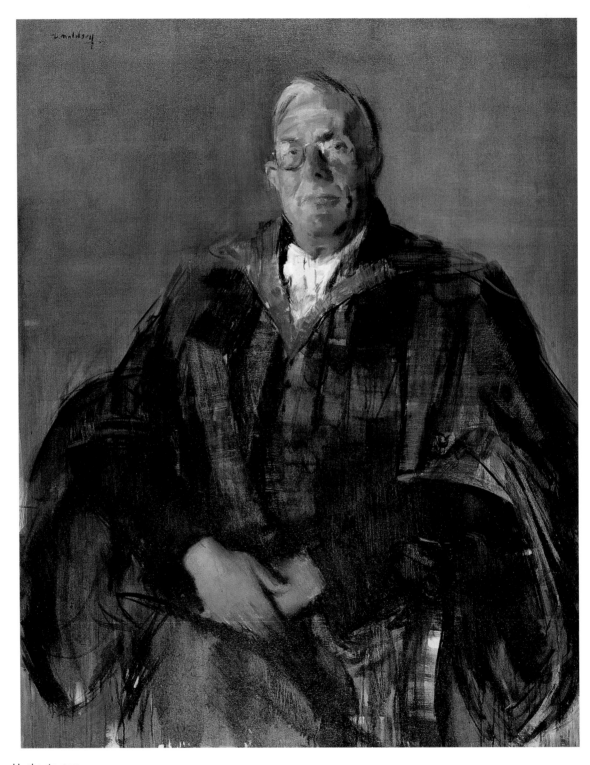

39. Sir Hector Hetherington,
1959–60

myself in my use of paint. Here was this old man, a great towering figure, and as I approached the canvas, it happened: the white horse came out to play. Now I entirely agree, that sounds vague. But the beauty of the paint that ran through the canvas was so persuasive for me that I didn't know what else to do. I was seduced into applying the paint the way I did. It didn't matter who he was. In a sense he was incidental. And I suppose that is true of all my portraits. I'm seduced by the idea of a painting – it comes upon me as seduction comes upon everybody. It's a beautiful sensation. Hetherington got in the road. I've got to try to come to terms – and so have you – with the fact that I am fastidiously grammarian about paint. The beauty of the paint is absolutely essential. If it's a bloody mess it doesn't matter a bugger whether it's like Hetherington or not. I had been seduced, freed from an otherwise drab and dull life for a moment, with the whole process of invention taking me over. It's like following the Pied Piper of Hamelin. After the dream, you're rudely awakened by the clamour in the Glasgow Art Club, or the press, and you're disappointed. One shouldn't be disappointed. The elation while doing the painting, whether it comes out right or not, is wonderful. And we shouldn't forget that I needed Sir Hector to be there. The rocket that flies off into space pushes itself off a base, needs power, so Hetherington was a requirement, because the energy that was generated was all about him.

GS *Then all hell broke loose.*

DD I suffered the most extraordinary vicious attacks from those persons in Glasgow University who thought he was a nice man. I hadn't analysed him. I made no judgments. To be fair, there were people who understood it as a painting. But no young painter could have put up with the abuse I got. When the University committee came to see it the professor of French dismissed it as idle idiosyncrasy. He had a point. It was in a sense. How stupid one can be. In a biography of Hetherington there's a chapter devoted to abuse. I'm called 'a poisoned dwarf' – a five-foot so-and-so, for Christ's sake. It was a bit hurtful. But I had been brought up in the religion of painting and I didn't know what the hell they were talking about. The price was six hundred pounds, huge money in those days. And the University has the painting. They realise now what they've got.

GS *How did Hetherington react?*

DD Sir Hector is credited as saying that he found the experience both 'an education and a pleasure'.

I had a strange experience with one portrait. It wasn't a commission. Hew Boyd was an eccentric Glasgow lawyer. I painted him in one sitting, deep in a November night, with Hew sitting there wearing a bowler hat (Plate 40). An odd thing happened in the studio. It was almost witchcraft, defying human experience. It wasn't the white horse seduction, but almost an ectoplasmic intervention, and in the portrait Hew was not just created, but in a strange sense *recreated*. I think of it as one of my great portraits. The Glasgow trams were still running, so we bought a poke of chips and rattled home as if nothing had happened. A very extraordinary experience.

There were others. Quite a few when, by some chance, I pushed open a gate into another dimension of thinking. And this is where difficulty arises. There are very few people behind you who can open the same gate. They're left behind while you go into wonderland. I've never been surprised, as in the Hetherington case, when people refused to sit beside me at dinner.

GS *What do you feel about conventional portraiture, the dreaded Kodachrome likeness?*

DD A nicer way of saying the difference between me and them?

GS *That might embrace a considerable number.*

DD Nearly everybody.

GS *A great many fellow Scots?*

DD By their works shall ye know them. Of course, I insist I'm not a commercial portrait painter.

GS *What about the portraits of Caroline, of Marysia? There are so many. Were they painted to please yourself, to find that elation you needed?*

DD This is a minefield . . . Let me go back a while. There's nothing quite so awful as the loneliness of the studio. I'm sure we're agreed that a talking still-life is better than a shelf of apples and cut melons lying decoratively. So, in the wee sma' 'oors of one's mind, whether you use your daughter or wife, they can conveniently fill the emptiness of an idea.

GS *Convenient and accessible.*

DD That's what artist's wives are for. When I had that wee studio beside the school of art, my training told me I should always be painting something. I can remember the lonely terror of setting up some stupid still-life. Later on, to avoid this, I painted one or two persons . . . just to get away from the eternal

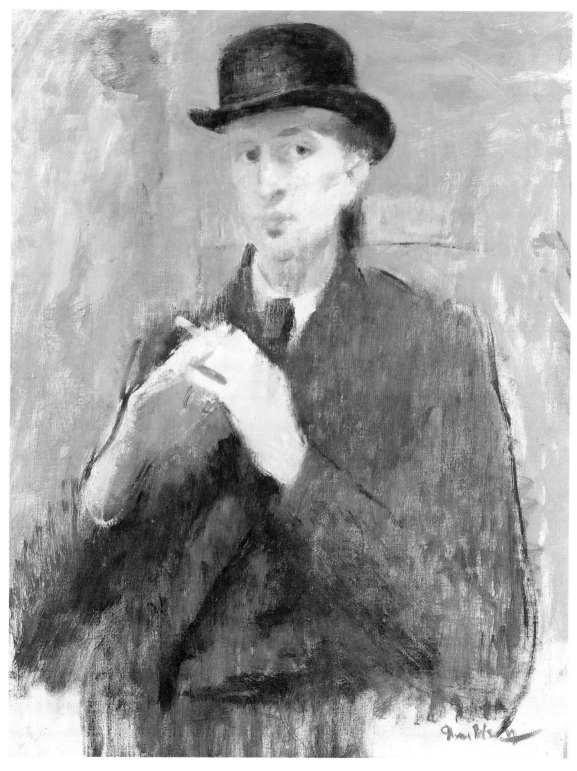

40. Hew Boyd, c.1955

41. Caroline in Chelsea, 1985

bits of fruit. So I had a person. And the person I had wore knickers – or no knickers, as the case may be. At one time it was no knickers, and it was wonderful. She became my first wife, actually. In no way a still-life – beautiful, and she spoke and had a being.

GS *I've been told that people sitting for portraits often behave as if they were in the confessional.*

DD Things people have told me are quite amazing, but they're safe under my care. I would never tell anyone.

GS *Do you feel they need to talk, out of embarrassment, maybe?*

DD No, no. I did the talking most of the time. It allowed me to paint without getting too self-conscious and tightened up. I taught myself to ask questions like 'how's your grandfather?'. I hated a colossal silence. I was sure the sitter thought I must be doing something very important, but my silence meant I was making a balls of it, I had a problem – something in the wrong place, the paint not right. I pretended to be involved but I had lost the thread. My mind refused to work. I was lost, demented, and the silence grew and grew. The spirit of the painting had deserted me, the impetus had gone. So I worked away at something I knew I could wipe out the minute they left the studio. Yeah, just that. But that decent person had been sitting there, maybe come a long way, and nothing was happening.

One of my happiest and most beautiful experiences was painting the cellist Joan Dickson (Plate 42), who was regarded as a brilliant teacher and performer. To be fair to Augustus John, there was a reminiscence of his famous portrait, *Madame Suggia*, in the Tate. My portrait of Joan Dickson is with the Scottish Arts Council. I had recreated the great Mackintosh studio at the school. It's a strange thing that, so far as I know, that studio was never photographed for an art book before it was turned into offices. I put it back to how it was conceived – immaculate, with a green floor, beautiful woodwork stained with water-paint, Mackintosh *par excellence*, and overlooking Glasgow. It was wonderful. Joan Dickson played as I painted – solo Bach resonating in the wooden studio, giving the cello such depth and colour. What an experience. We were putting up a paean of praise to something or other, something very special. In one of the most beautiful settings Scotland could produce I was painting a six-foot picture

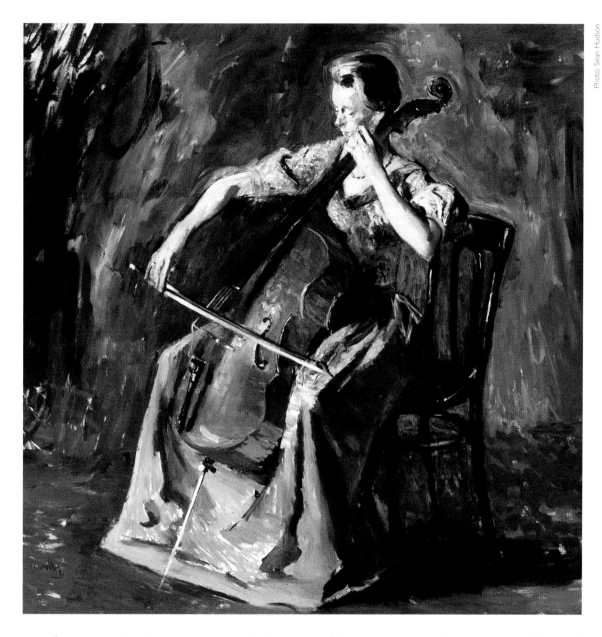

42. Joan Dickson, 1975

of a woman in a long green dress playing some of the greatest music in the world. It was magic. The BBC should have filmed it, made some record of all those beautiful things coming together. I loved that studio. For the students who came into it as kids – as I did – it was a wonderland. But as schools of art became responsible to accountants of the public economy, that beautiful space was transformed into a place to keep records.

GS *You say you regret that the act of painting the portrait wasn't filmed. Surely that's a contradiction. You painted the experience. It will be of interest, I'm sure, to people who see the portrait to learn how it was painted. But that's*

background; the portrait is foreground. I think all you need do is look at the painting, try to understand why it works so well, enjoy it, and anything you hear about the ambience in which it was created is bonus.

DD Well, yes. I would like to think that.

GS *That's the circumference of everything we've been talking about.*

DD There's no such thing as an ordinary person, but in some ways Joan Dickson was the ultimate. Everything was so beautiful. But in those days the school of art was beautiful. Even our army of cleaners. I was accustomed to the most extraordinary help from these Glasgow cleaners. I can still hear them: 'Are ye a' right, Mr Donaldson?' It's very, very clear to me now that it was in that place, as the Bible says, where things came to pass. A meeting place for all the rivers of the mind, where there could be a confluence of good ideas. Where good people taught me, or tried to teach me; who would come along and see me struggling – like old Somerville Shanks – 'Could I borrow your palette, Mr Donaldson?' And in a flash: 'Behold; they were blind and now they can see.' Of course, that Edwardian education, which insisted that I needed to know professionally and aesthetically what I was doing, created its own dilemma. I was confused, and remain confused. Since about the age of twenty-two I've been exposed to a plethora of ideas. It would have been better if I had been trained to use technical methods to express these ideas, solve my problems – basic problems, but because they're basic they are monumental.

GS *You seem oppressed by this absence of certainty, this not knowing instinctively whether you should have done this or that.*

DD It has been a problem all my professional life. Which route to take with a riot of ideas. I go down one road and find myself in a jam. I can't do anything else because I'm too stupid. If some calamity had struck me, how could I have done anything else? I'm too thick.

GS *I'm certain you would have found something interesting to do.*

DD I would have opened a chip shop.

GS *Right, but it would have been the best chip shop in Glasgow.*

DD Okay, I'll buy that.

Donaldson is naturally disputatious. Years of teaching from a position of authority, where he held the floor by right, have given his vocal delivery a

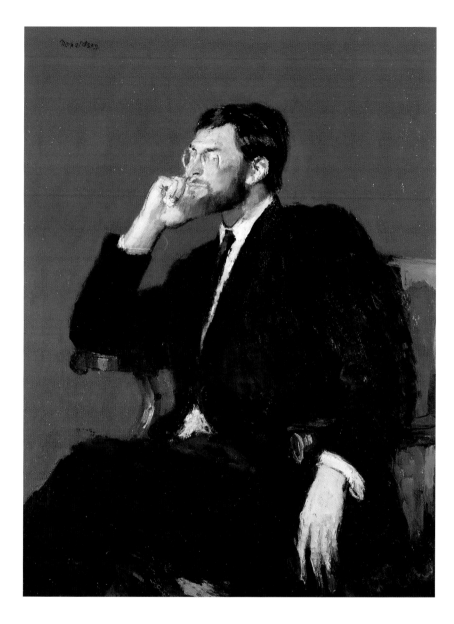

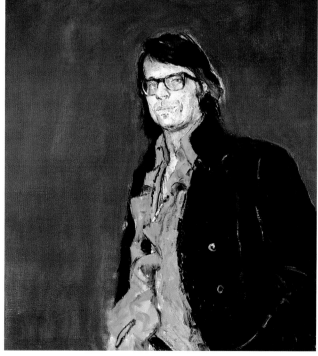

LEFT
43. Rabbi Jeremy Rosen, c.1969

BELOW
44. Bobbie McIntyre of Sorn,
1974–75

declamatory edge and, when he knows he has gathered together the right order of words, a gallus confidence which does not anticipate interruption. On his way towards a reasoned response to a question he will harumph a bit, swear mightily, take the Lord's name in vain, change the subject spontaneously and illogically then, when he has gathered his wits, break off with a whoop of laughter or multiple curse and pick up where he left off. If he suspects that his proposition might be too extreme he will demur in advance or at the conclusion of his thesis inject an interrogatory, high-pitched 'Hmm?' – a mannerism deployed so often in public address by the late Jean Muir that it almost became an affliction.

He gives loosest rein to those caustic opinions he has honed over decades – about east coast painters, women painters, so-called Glasgow painters, other portrait painters, about art school administration, pettyfogging bureaucracy, and the overwhelming public ignorance of the nature of painting.

His friends say he has not mellowed with the passing years, that he is if anything even more truculent, and probably finds it impossible to strike new attitudes when the old ones are so solidly set. Jargon and imprecise usage of words offend his love of language. He jumps on words like 'creativity' and 'integrity' and demands to know what you mean by them. Even 'art' offends him – 'a nasty wee word; it doesn't even look right'.

Today, portraits of sovereigns and princes are less necessary than in the days before photography, when it was incumbent upon court painters to record royal visages for posterity. The tradition of royal portraits has persisted, however, and throughout this century Britain's royalty has patiently sat for scores of limners who have been commissioned by galleries, institutions and organisations patronised by the royal family. Donaldson was commissioned to paint the Queen in 1966, eleven years before he was appointed Painter and Limner to Her Majesty the Queen in Scotland (Plate 45).

> You don't get medals for good intentions. I continued to make the tragic error of thinking that people were interested in painting. What a fool. We've talked about the sitter and the artist being exposed in an extraordinary way, and when you're painting your Queen it is extraordinary. I anticipated the scale of the problem, of course, but was never tempted to make it easier for myself – as others have done – by taking photographs or making preliminary sketches.
>
> I think Holyroodhouse imagined they wanted me to go to London and paint a rather grand postage stamp. They had decided the size of the canvas

to an eighth of an inch. I said okay. There was a niche at Holyrood Palace where the portrait was destined to hang. Basically, they chose the wrong painter. A lot of men spring to mind who were satisfactory and could have done what they wanted. I was about fifty-something, but a long way away from being mature enough to understand how the world wags. I thought painting the Queen was what Velazquez did, only he would have done it better.

I'm not accustomed to royalty. But in my innocent way I was excited, and the price was a thousand pounds — a lot of money — but it cost me that living in London while painting the portrait. So I sub-let a studio above old Augustus John's studio and it all became part of a London romance handed to me on a plate. We lived in the studio for a day or two before the first sitting. I had been to the palace the day before, set up my easel and canvas, saw the Queen's wardrobe, met her dressers and all that. The commission decreed that she should be represented in the robes of the Order of the Thistle and I chose a beautiful silk dress as her undergarment.

The big polisman at the palace gate spoke to me. I said, 'D'you come from Airdrie?' 'Aye, I do, actually.' I'd recognised his Monklands accent. Up in the room where I would paint I was confronted by my pure white 6' × 4' canvas, a bastard shape to work with.

I don't want to labour the point, but this wee chap from Coatbridge Secondary School was standing quietly in the centre of the Empire waiting for this little girl on an overcast November morning. I kept looking out the window, shuffling from one foot to the other, and listening to the band, soldiers enacting the Changing of the Guard jumping up and down, and big horses jumping up and down. I was there about an hour before she was supposed to arrive. As time went on I got frightened, and more frightened, until there was a rustle, the kind of rustle of rats jumping about, and the door opened. Two footmen — and in comes Her Majesty.

I've never seen anything so beautiful in my life. She was absolutely adorable, absolutely wonderful — and all this panoply of stuff, millions of pounds' worth of jewels and drapery, and this northern light coming up the Mall and into the room. It was staggering. And I make this point because, at the end of the day, it was my big mistake. I set out trying to paint the idea of that light falling on this person — it could have been anybody.

She was gracious. She said, 'Morning, I'm afraid I don't know who you are.' I countered and said, 'Yeah, that's all right, I know who you are.' She climbed

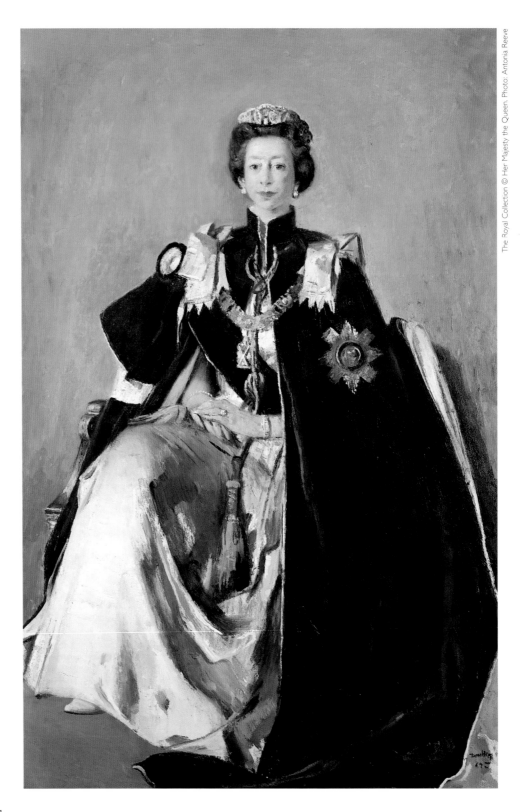

45. Her Majesty the Queen,
1966–68

on to her throne and the band played, and the horses neighed and jumped about. And there she sat, in her own home, and I had to paint her. It was murder – like diving naked into freezing cold water. There was no help, nothing I could do about it. I had asked for it. I had got it. Go on, deal with it. And so I started. It was similar to the Hetherington portrait – like a vast watercolour, washed in with thin, thin paint.

At that first sitting, all I was doing was declaring my intentions. I was attempting a kind of Elizabethan charm with these thin-washed paints. It was just a jittery aesthetic reaction by a wee nervous man to a huge problem. The second sitting was virtually a repetition of the first. We chatted, or rather she chatted, little anecdotes about the Coronation and so on, while the band played or the horses neighed. This went on for a few days. One of the tricks they play is to grant you initially only a set number of sittings. I think the idea is to see whether the Queen can stand you or not, which is fair enough. At this juncture I have to tell you I had thirteen sittings – which were thirteen opportunities to make a balls of it.

All I got in the way of sustenance was a carafe of water with two glasses, one for her and one for me. One day I got an outside line and phoned Marysia in Chelsea. 'Bring me something to eat, I'm in a hell of a mess.' That day the canvas was a shambles. Marysia brought fried sausage on rolls. Maybe I could have ordered bacon and eggs from the palace kitchen, but I'd already made a terrible mistake with a footman. I asked him if water was all they could afford. He said, 'What do you wish, sir?' 'How about a little whisky?' And he brought me whisky and of course I had to drink it – I didn't want whisky, it was only something to say, because of those embarrassing water glasses.

I went on and on. She was very patient, very nice, told all sorts of funny stories, about the Duke arriving at a station to welcome some noble person coming from India, the cavalry drawn up and everything, and they were at the wrong station.

It must be boring for her, sitting for all these miserable painters from all over the place. But of course she's not just come from washing the dishes. She's in her own house, with her own hussars charging about. She hadn't all that much to say but we weren't there to hold a conversation. One day she talked about having just come back from the stables, and she was addressing me as if I had stables, too. I must have seemed to her like a person from outer space. Occasionally she would make a wicked remark or two. She was very

nice about Churchill and decent and kind to me.

Then there was this beautiful and wonderful moment one day while I was painting her. Suddenly, from away down the Mall came the pipes and drums of one of the great Scottish regiments. For me it was terrifyingly stirring and moving. I mean, to hear the pipes skirling up the Mall, and me with the Queen inside Buckingham Palace. It was incredible. I told that story to an old guy I was painting in Edinburgh and he broke down in tears. And I know why. If you needed a regiment to march through Europe and knock fuck out of the Russians, that's who you would send.

It was about that time I realised I had got caught up in the still-life syndrome. I wasn't painting the Uncle John likeness at all. I was painting the beauty of these dazzling jewels and the light on her and them, and Uncle John had gone. She gave me thirteen sittings and I was told many years later that only Augustus John – painting her mother – and I had been given that sort of time and had not resorted to photography. That pleased me a lot.

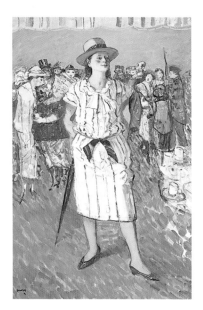

46. Marysia at Royal Garden
Party, 1987

When my portrait was exposed to the public it created quite a fuss. It's basically true that I had brought all my emotional and dramatic excitement to a still-life, to an event inside Buckingham Palace, and not to the lady I was painting. Over more than a year she gave me all those sittings and I dreaded every one.

One day on her way out she paused and sort of looked at the canvas. I had been clawing away, trying to work out something, and the painting was dreadful. I said, 'Don't worry, ma'am, it'll be all right on the day.' I felt utterly beaten. The whole thing, the containment of an idea, had flown. I had renegued. I had been given a totally free hand. I could have taken the first sitting, and then said – well, maybe some other time. But I thought it was the honourable thing to do, to carry on. Maybe I was frightened to quit. The subsequent row would have been terrible.

People have told me that Holyrood Palace warders are apologetic about the portrait to visitors. I have to keep remembering that in some ways it was my happiest moment. The only person in public life who was kind was the painter Sir William Gillies. But somewhere I have a letter from the Duke of Hamilton, regretting that I didn't leave the palace after the first sitting. That was his view, and to a large extent he was right. But at the time I thought if I left it alone I would go to jail.

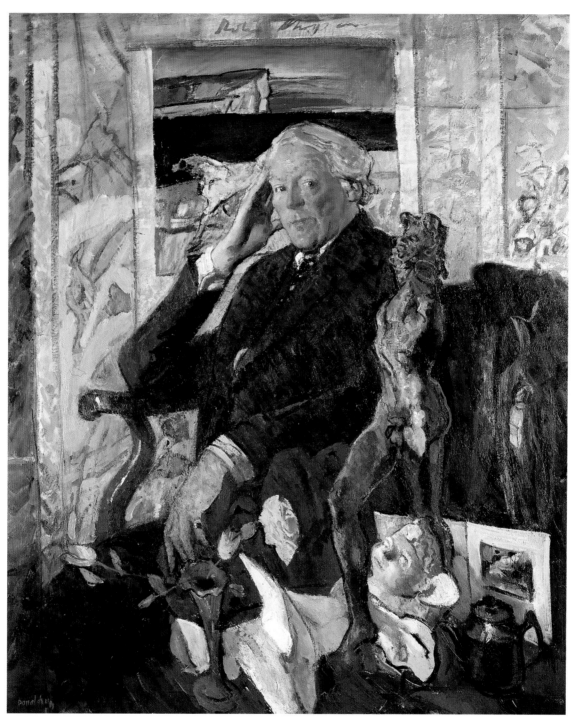

47. Sir Robin Philipson PPRSA, 1987

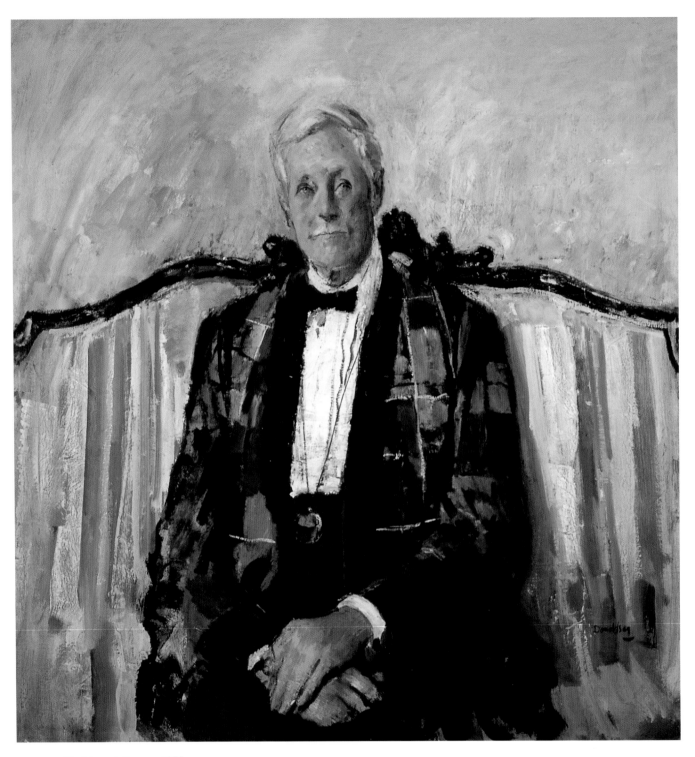

48. Edward Denny, 1975

With Margaret Thatcher I was up against it in a big way, and I made colossal mistakes. But the intentions were again of the very best and it was a fantastic experience. The English are pretty smart cookies. At that time I was having – if you'll excuse me – bladder trouble. That's to say, I was peeing all over the place, which is not really on if you're in Chequers or Buckingham Palace. It says a lot for Maggie Thatcher that she had it all sussed. Chequers is wonderful. Only the English can make country houses like that. It looks so innocent – not a gunman in sight, which is of course a fallacy. Anyway, I arrived on time, the last ounce of pee hopefully drained out of me.

I was used to footmen at Buckingham Palace, but there she was herself, opening the door. Standing behind her was a great big black policewoman, modestly armed. 'Oh, good morning, Mr Donaldson,' says Maggie and hustles me in. She was rather like a Bearsden housewife, full of charm, and insisted on taking my case upstairs. But the minute I saw her I knew I was in the presence of star quality – up against it in a big, big way.

One of her staff said, 'Prime Minister, you're due at . . .' 'Would you excuse me, Mr Donaldson?' . . . she couldn't have been nicer. I wasn't there to say hello to her. I had settled on some sort of idea for the painting and here she was in the middle of the Westland helicopters crisis. Anyway, I started. This was not the way I really wanted to proceed, but – and it's fundamental in a way – once you find a key to the whole design of the canvas you're at least halfway there. And, of course, whatever you do, it's full of dangers and traps.

Margaret insisted I should have tea and Christmas cake – more than the Queen ever did – and I was shown my little lavatory. I had only three sittings and had to arrive every day at eleven. I wrassled about and tried to achieve something, but it was difficult. Again, I'd dived naked into the pool. On my last day I got a phone call from her secretary, all so polite, rearranging the sitting for two o'clock. As I subsequently discovered, that was the day she had the big punch-up with Heseltine over the Westland affair. She came bustling in furiously, but without a wrinkle on her brow. There was never much time for conversation. I remember asking her, however, what it was like to be Prime Minister in all the heat and battle of Question Time in Parliament. She hesitated for a second. 'Well, you see Mr Donaldson, I'm dealing with amateurs. All my facts are absolute iron when I go into the House.'

I messed about with that portrait. It's really vital to understand that I had decided on only three sittings – like writing a short story instead of a novel. A

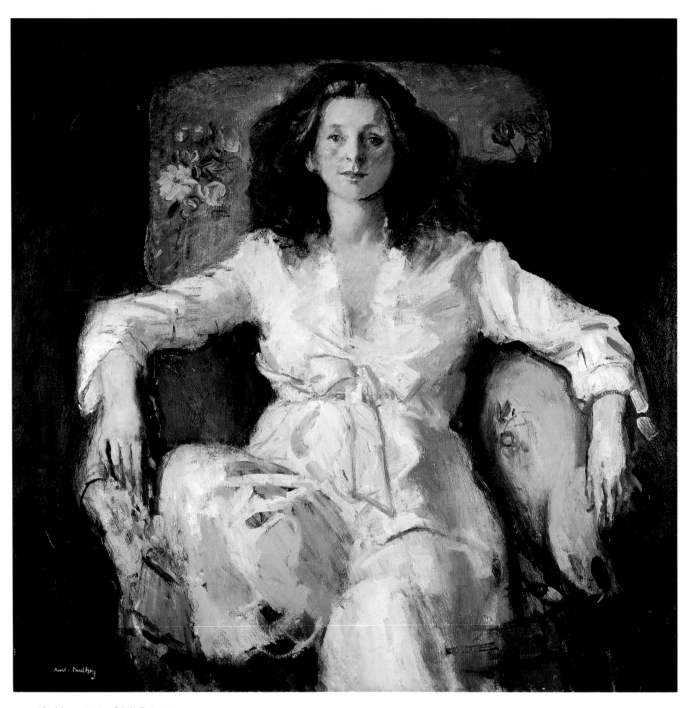

49. Marysia in C&A Pyjamas,
1978

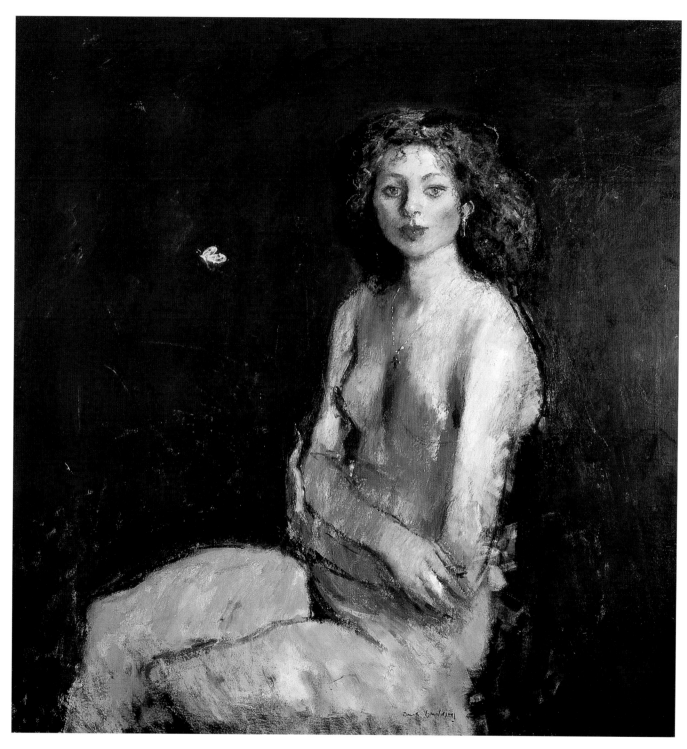

50. Annette, c.1977

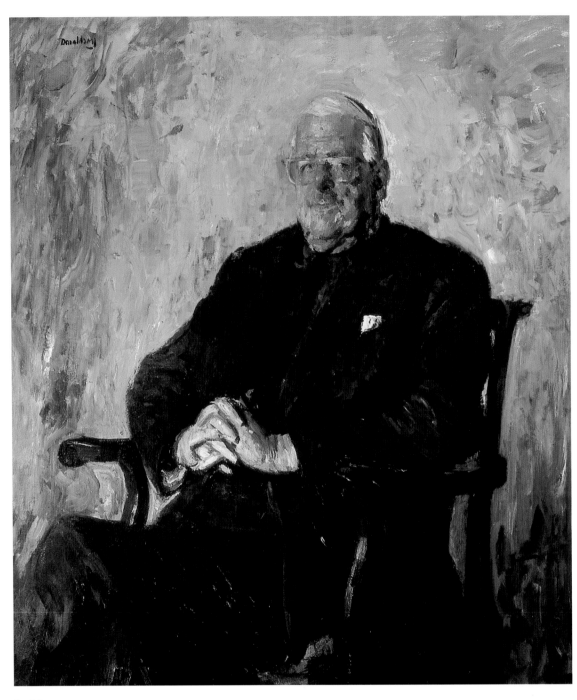

51. Lord Macleod of Fuinary,
1966

difference in scale, in how and what you can say. Strangely enough, at the last sitting Mrs Thatcher asked if I could come to Downing Street at some time, to finish it off. And that's a clue, because it didn't matter to her, or to most people, that I would be taken into a different atmosphere. And I said, no Prime Minister, I have written a short story, and I stand by it, I defend it. Of course I could have got photographs from her and tidied it up, but no, no thank you. Three sittings is a difficult proposition. Fortune prevails. Luck has to be with you. The way I see it is that *I took a chance* on three sittings.

🌼 🌼 🌼

Donaldson's portraits, whether thin washes of colour swiftly achieved in one sitting or heavy impasto which has been worked and reworked over months and even years, have two things in common – a quality of living presence, as if the painter has brought the very person of his subject into our company; and – perhaps the secret of that magic – an innate energy, which was first generated through a communion between artist and subject, which galvanised the physical dance of his brush, and by some alchemy transmuted inert pigment into organic life.

He uses the word beautiful very often, stretching out the syllables separately, cooing *beau-ti-ful*, and this is the phantom he pursues in his art. The beauty of perfect things perfectly accomplished, of human and natural beauty, of the apt and appropriate, of proper things in proper order, of decoration and handiwork, of serendipity and happenstance recognised and exploited, of the poetry of words and music, tone and texture fused in ultimate complement.

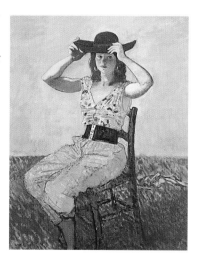

52. Caroline in a Red Hat, 1990

Many of his portraits achieve these, his own, most demanding standards. He has painted his daughter Caroline from childhood to motherhood, from an infant party pose in a clown's cap to the teenage beauty relaxed in the frugal elegance of *Arrangement in White*, to the mature woman in her 1993 red hat (Plates 4, 20, 29, 41, 52 and 66). Marysia's image strides through his adult painting life, never less than attractive, frequently as beautiful as a Meissen figurine, and perhaps at her most gorgeous in C&A pyjamas (Plates 5, 46, 49 and 100). His model Annette Carberry was a constant nymph (Plates 37, 50, 64, 65 and 72). He saw serenity in a beautiful student Catriona Campbell (Plate 54), intelligent authority in Isaac Sclar (Plate 31) and ascetic rigour in the profile of Rabbi Jeremy Rosen (Plate 43). Dugald Cameron, now director of GSA, leaps

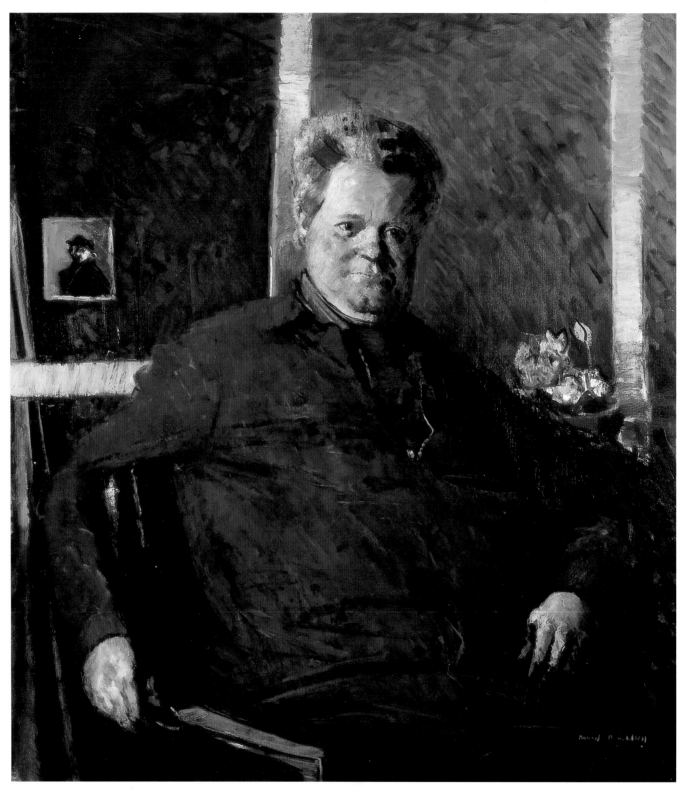

53. Dugald Cameron, 1980

lifelike from the canvas (Plate 53). The character of Sir Samuel Curran is revealed so powerfully that not even the majestic red and gold of his robes diminishes the man.

Then there are the self-portraits. In my biographical play about Vincent Van Gogh I have him at his easel, unhappily painting himself and saying: 'Rembrandt painted his self-portraits as landmarks in his long life. He always knew what he was and painted what he was. I paint myself to find myself. Every portrait is a part of me, yet none is completely me. I paint what I see then ask myself what it is that I have seen.'

A high percentage of Donaldson's self-portraits suggest that this was also his purpose. They are not so sombre as Rembrandt's, are in no sense ravaged like Vincent's, yet despite their often jaunty and deliberately comical cast – naked with chef's hat and cactus, the 'potty' portrait from 1935, chef's hat again and butcher's apron, and David in a smart suit with a fish supper (Plates 16, 55, 56, 57 and 58)– he seems to be charting a voyage of self-discovery. I believe his *Self-portrait in Winter*, explicit in its mood and attitude, is one of his masterworks (Plate 103).

Today, he misses portraiture and poses an enigmatic question:

Because of ill-health I haven't painted portraiture for quite a long time. Partly out of respect for my sitter – because I don't think I'm strong enough now to do it – and partly because I know the terrors and don't know if I could face them. I painted portraits within the limits of my nervous and intellectual powers – and I stress the nervous because of the potential consequences.

The intolerable tension comes from that permanent question: how does paint fall on the canvas, as snow falls on the pavement, and fails to cover up the hot spot?

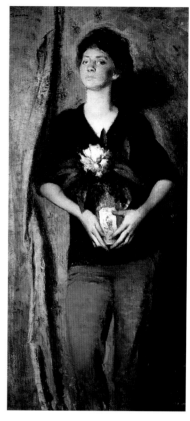

54. Catriona, 1961

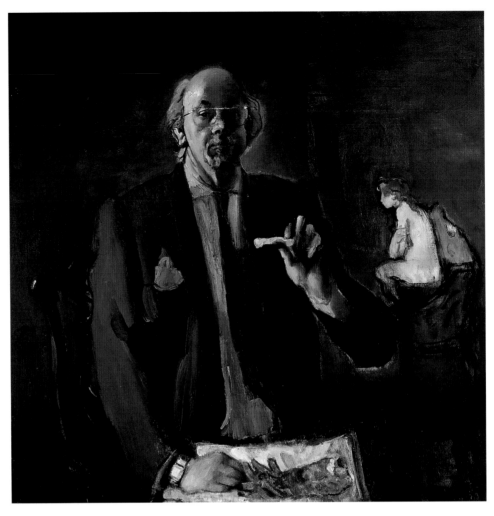

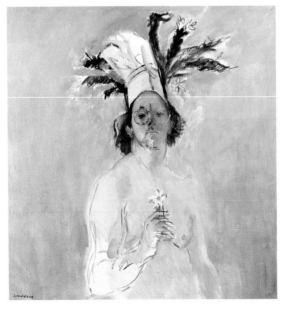

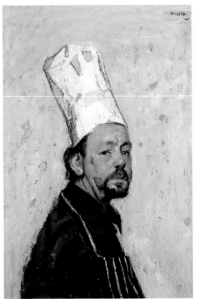

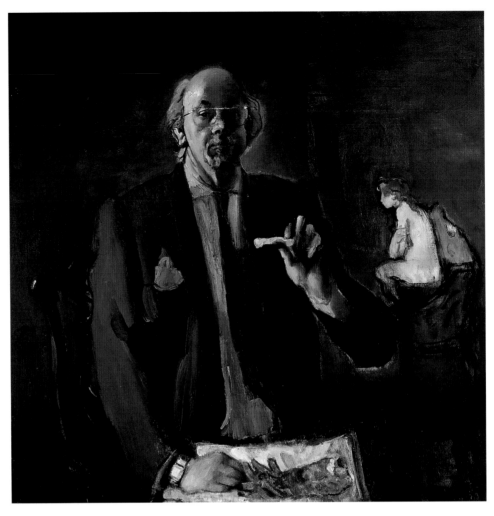

TOP
55. Self-portrait with a Delicacy,
1993

BOTTOM LEFT
56. Self-portrait with Cactus,
1974

BOTTOM RIGHT
57. Self-portrait with Chef's
Hat, 1967

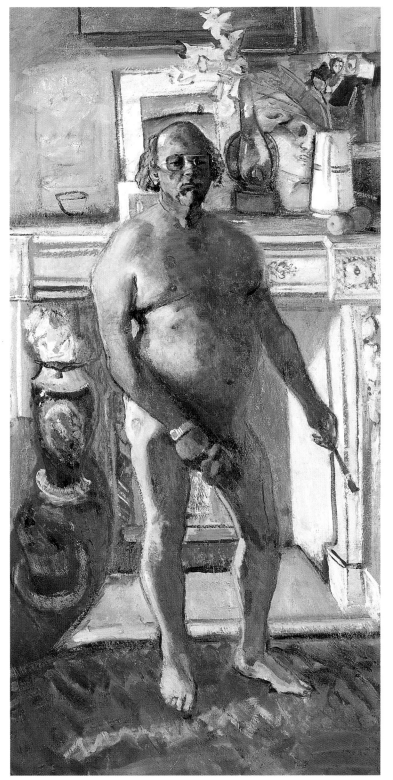

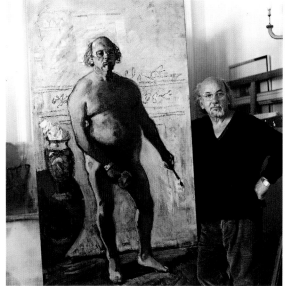

LEFT
58. Self-portrait, 1986

TOP RIGHT
The artist and his work

RIGHT
On the cover of *The Art
Magazine*, 1981

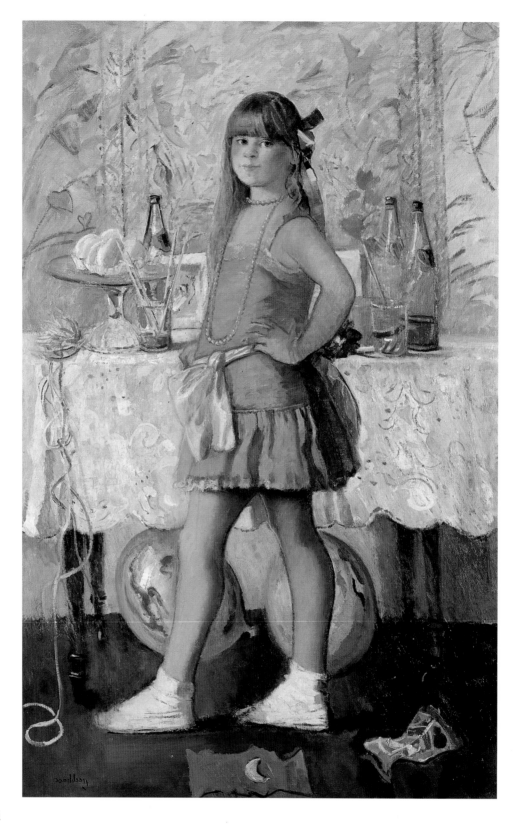

59. Kara, 1982

HEAD OF SCHOOL

The day came in 1967, after twenty-three years of full-time teaching, when David Donaldson was appointed head of the department of drawing and painting at Glasgow School of Art. His marriage to Marysia Mora-Szorc, tempestuous but secure, had produced two daughters, Sally Mora in 1950, Caroline Mary in 1956. He had already accomplished a great deal – against all the odds if his Coatbridge origins, his lack of academic qualifications, his quirky character and maverick behaviour are taken into consideration. In 1962 he was elected a full member of the Royal Scottish Academy and became a member of the Royal Society of Portrait Painters two years later. His portrait of the Queen was still in progress. Aged fifty-one, with much of his mature work still to come, he accepted the responsibility of one of the most important and potentially influential roles in Scottish art. He succeeded William Armour.

60. Sally in a Moses Basket, 1951

Willie was one of the most honest of men. In a way – wickedly, I suppose – one could say that he wasn't quite the vital spark, but fantastically honest and decent. I remember there was a row about a girl who had been failed. There were those who thought that because of some circumstances she should have been passed, but Will's point was that she had sat the same test as other students; she wasn't good enough, and that was that. He had that kind of integrity. He was valuable. A teacher, of course. In the life-class he was like the head priest with his acolytes, training them in draughtsmanship right up to the last minute.

My appointment didn't come as a surprise. I suppose if you're halfway up the ladder you're really quite anxious to push the other bugger off, it doesn't matter where he falls. I was impatient with this honest man, because I actually felt that my own form of dishonesty was better.

Armour's honesty was the honesty you get from the milkman who collects the tokens each week and returns them faithfully, yea unto the end. I was weary.

There was this constant search for the truth. My dishonesty lay in the fact that I didn't really know what the truth was. The atmosphere was heavily laden with tales of great painters – from Cézanne to John Cunningham – convenient stories you use when you really don't know what art is all about. It's easy to point people in the direction of Velazquez. You're actually avoiding the problem, because the student says how can you paint like Velazquez in contemporary Glasgow? I was unable to accept – and still am – a truth which I don't understand. I know no really creative person who would disagree with that. There's no point in preaching parables about the truth which evade the truth.

Willie Armour belonged to another age, spent his weekends drawing sentimental pictures of little girls. To me the head of the painting school in Glasgow was, and still is, something of consequence. It was a heady sort of thing. I fell for the grandeur. And in those days, relatively poor, even an extra two pounds a week was worth having.

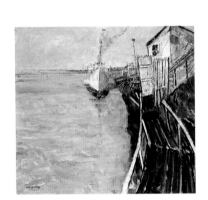

61. Maid of the Loch, 1980

When I took it over I was fascinated by the lifestyle. It was cheering to have a telephone. Robin Philipson had a secretary in Edinburgh. I never had a secretary. These trappings had become the hallmarks of status and board-room power. They had nothing to do with painting.

I realise now that the school had been going to war with itself in all kinds of ways. There was the Forrester Wilson/Hugh Crawford tradition of aesthetics. There was still a remnant of the art nouveau tradition, exemplified by Mackintosh's wonderful building and Ancell Stronach being regarded as a second-rate Greiffenhagen. All these influences were there and at war. We'd lost the stylish tolerance of Bill Hutchison's spacious age. The finest finishing school in Europe no longer existed.

That man from the Slade, Harry Barnes [Sir H. Jefferson Barnes, director of GSA, 1964–80; the 1995 history of GSA says his accent 'was of an upper-crust variety now more or less extinct'] and his cohorts had no bloody time for the school or the tradition of painting in Scotland. They did everything in their power to destroy it, to strip the place of its history and character and some beautiful Greiffenhagen portraits and other important artefacts which have all gone. Our great drawing tradition was dismissed as backward-looking. I believe it was a genuine attempt to destroy a whole idea.

Of course I was not popular with the establishment. By that time we were inundated with the English – on the principle that anything from the south is bound to be better than something in Glasgow. I was never stupid enough to

believe that most of the English were good simply because they came from the Slade and places like that. If they were hell of a good they stayed down south and we got the export rejects. They hadn't a clue about us. They spoke to us as if we were primitive natives. I just couldn't take it, and when I had the power I put the boot in; I went to war in a big way.

I spent hours at the end of every year looking through Christ knows how many portfolios. The cleaners could have done it just as well. They would have said, 'I like that one, Mr Donaldson, don't you?' And I'd say 'Aye, that's all right.' Instead of that, my staff – who, at that time, were mostly brilliant – had to waste endless hours with me on a pointless exercise. Why haul up London assessors? They didn't know the students, what they'd been asked to paint, whether they'd been allowed any leeway. How could they judge? Except subjectively – the same as the cleaner: 'I like that,' or 'No, no, Mr Donaldson,

62. Macfarlane's Yard, Loch Lomond, 1983

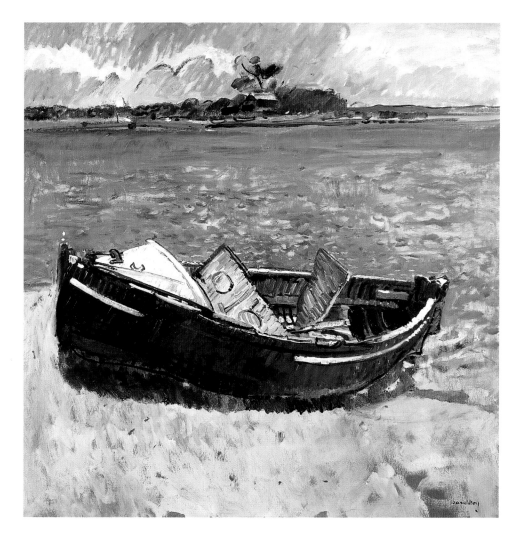

she shouldnae have painted her haunds like that.' The whole core and fabric of that system is ludicrous.

All the art colleges were working desperately hard to get government funding. I always thought a school of art should be a place where some wee lad like me could come and say, 'Hullo'rere, I want to paint like Rembrandt.' If he's taken in, the boy soon discovers that he'll have to paint the way the colleges want him to paint.

One wee girl in the first year came up to me saying, 'Mr Donaldson, they've asked me to press my back against a wall and then draw the experience.' Now, there was a time in Glasgow when, if you had your back pressed against a wall, it was probably up a close – and led to an interesting experience. That's the kind of rubbish which was being passed off as teaching.

Before I left I dreamed of a new type of art school which didn't need so much public funding. I would interview students, and the only dishonesty would be my pretence that I couldn't tell them what to do. I would suggest that in my experience one or two things seemed good to do. Like Thursdays, you'll draw all day. Under a first-class draughtsman who would train you in that and nothing else. Figure painting and composition used to be Jesus on the cross with holes in his hand. You would tell them that composition is now a meaningless subjective term. And so on, getting rid of the rubbish and the lies. You would give them lots of time to do whatever the hell they liked and provide workspace to play around in – in which case you wouldn't need the splendid building as the school of art, you'd put them in a garage.

My first wife was probably more astute than anybody I know when she said that students should be given four thousand pounds to keep them off the streets, and just let them do what they want to do, instead of forcing on them an assemblage of ill-sorted ideas from such a variety of sources.

The more I struggled with this problem the more I became helpless. Objectivity can be satisfied sometimes with one question: can the student paint? And I mean in the engineering, technical sense. I had many run-ins with the education establishment, but a big one involved the then school director over honours degrees. To a large extent he had a point. He regarded the honours degree in university terms; there should be evidence that the student did something extra. I wrote a paper, one of the few things I ever replied to, agreeing that it would be valuable to find out if students knew their business, how well they had assimilated teaching, if they had investigated the whole

Donaldson painting his grandson
David playing the tuba

physical process of painting and could write a paper on its care, or the care of any art things. That was shot down very badly.

The power struggle reached the limit for me in the years before I retired. The staff were defying the great traditional laws of oil painting. For instance, I had insisted on the teaching of basic priming techniques, what kind of linen or cotton they were working on – and that they shouldn't really be painting on cotton at all. I was speechless at the inadequacy of what was going on – people working on the reverse side of hardboard with hogshair brushes. This was lunacy. The whole thing had become insane.

Eventually, before I left, I painted my *Self-Portrait in Winter* which, I hope, expresses the winter of my discontent, my clear dissatisfaction with everything that was happening at the school.

Many former students have told me how, on rare occasions, they were privileged to watch Donaldson at work in his restored Mackintosh studio. For most of them it was an inspirational experience – magical for reasons which neither they nor Donaldson can find the language to explain. The ambience of the studio itself, which Donaldson has described so vividly in talking about painting the Joan Dickson portrait, created its own dramatic tone. It was a place to aspire to, a facility available only to those who had reached the top of their profession; an incentive, if ever there was one, to succeed. And Donaldson never forgot the day of his dressing-down in Forrester Wilson's studio, when he began to understand what painting was about. He remembered, too, that all his own teachers, notably Crawford and Fleming, had been exceptional demonstrators.

In the studio c.1963 working on a second version of *Annette and the Elders*

So when they came to watch me in my immense and beautiful studio I wasn't doing anything essentially mine or original. I was trying to carry on the school tradition.

In my young days the studio doors swung open and the master entered in total silence. You could have heard a pin drop as Crawford or Fleming walked around, and I've seen them correcting every drawing. As time passed and customs loosened up, all that became history, and nothing to do with me. Originally the studio woodwork was treated with dark-green non-reflective water paint. I restored it to that immediately. That was clear in Mackintosh's mind yet I've never heard anybody else talk about it. He wanted the painter's

background to be dark with no reflections, like a morgue in a way, where you could examine the corpse.

I looked for something livelier. The whole of life was changing. All those young dolls were coming into the school, the pill had been invented, a new game was on. So I did a bit of loosening myself. Willie Armour was extremely decent. I was not, but conscientious in other ways.

I'll tell you how it was like. I would motor in from Drymen on Loch Lomondside in my Jaguar. I used to say to students: by the time you're thirty you must have a Jaguar – none of this art stuff. So I arrived in a Jag. People still touched their forelock and I made the most of it. Then up to the studio. By this time it's ten o'clock; school had started at half past nine. I'd make tea in my beautiful little kitchen, then go down and throw open the third-year studio door, and say in a very loud voice, 'Youse can paint fuck all,' then turn on my heel and leave. This is true – and they thought it was wonderful. They knew it was an act, a carry-on, and when people are basically decent and lonely and pissed off and don't know where the hell they are, they enjoy that sort of thing. And occasionally, especially if she had good legs, you could say, listen, you better come up to my studio and I'll tell you anything you want to know. I considered myself to be the rightful owner of the legend of Greiffenhagen. I was the natural receiver.

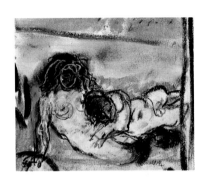

63. Two Nudes, 1978

Most of my demonstration paintings were done downstairs in the big studios. I did as I'd been taught. I would, of course, speak loudly about the paintings, and ask what they thought they were trying to do in the first place, 'your palette's a bloody mess' and things like that. It was showmanship. Most of them swallowed it.

I can think of one wee girl, she was about four foot two, who told me she was pregnant. I thought, how could you possibly get pregnant? It must have happened in a coal cellar. I told her not to worry about it; we'd probably give the wee wean its diploma. This became part of the Donaldson legend, but my staff deserve some of the credit for accommodating the lass. I told her to go and have her wee wean, come to the school from time to time, and she did. But the world being what it is, I had to warn her that she'd better show some progress to protect her from the attitude of fellow students. Anyway, the wee wean got its diploma. And there was toleration of all kinds of other daft buggers. What kind of book did I have to throw at them? I was as confused as they were. So the best way to teach them was to show them what I could do.

We're talking about kids of about nineteen. I came in to the life-class one day where they were all busy painting and Bill Crozier was working on a canvas. Acting the smart guy, I said, 'How many fingers on that hand?' He said, 'Six.' We just left it at that. I encouraged the core of my staff to have an occasional studio piss-up. I tried to create an atmosphere in the painting school in which something could happen. I didn't know what it was that had to happen, and even the statement I make now sounds overgrand. I just had a simple idea that students and me could agree about one thing – that the world had two arms and two legs. Anything else was subjective. I had very little difficulty with students. If I took anyone out of the class, students were left with the feeling that they were getting special treatment. It was a deliberate act.

I have spent most of my adult life in the Scottish arts community and many years in the intimate company of painters. David Donaldson's name has been summoned constantly over forty gossiping years – jokes, anecdotes, tales of outrageous behaviour, acts of furtive generosity, bullying, compassion and, of course, unstinted admiration of his formidable talents as a painter.

Much of this fabric of Donaldson's life was woven round his years at the helm of GSA. I could have fashioned a collage of reminiscence by ex-students and staff, but realised that there might be too much gushing gratitude, too many old scores to settle, and inevitable repetition.

I decided to ask a trusted friend, the painter Alexander Moffat, to think through a synthesis of his own reactions to Donaldson, his personal experience of the man, the way he ran the school, what he had seen and heard for himself and to recount some of the tales which had fertilised the Donaldson legend.

Sandy Moffat is uniquely qualified. He can claim the neutrality of coming from a background on the dreaded east coast and training at Edinburgh College of Art. He is a distinguished portrait painter. Donaldson appointed him to the staff of GSA in 1979. Moffat's leadership of a revival of figurative painting is widely recognised as the influence which led to the international recognition of GSA's new 'Glasgow Boys' during the 1980s. He has been head of the drawing and painting department since 1992.

For someone who had been brought up at a comparatively genteel Edinburgh College of Art, where the staff could have been Church of Scotland ministers at the Assembly on the Mound, meeting a real live Glaswegian character like Davie was a shock to the system. He shouted and swore at students. At the drop of a hat he threw a party, stripped to the waist, and danced all over the place. It was exactly how you believed artists should behave, how you believed Picasso had behaved. He had quite a bit to say about Edinburgh. One day, out of the blue, he said, 'D'you know, I'd never heard about Edinburgh until I was forty-five.' Looked me straight in the face and just came out with it. He was a mass of contradictions. A great insecurity, stemming perhaps from his strange childhood, ran right through him. He could be very encouraging in a life-class in the morning and in the afternoon something would annoy him and he would tear the students apart. He was like that with everyone. Many of his staff found Davie very difficult to work with.

He was wonderful to watch as a painter. In a sense that was the best kind of teaching he could give. You can't beat watching a really good painter paint. I learned a lot from watching Willie Gillies pick up a brush, even if he just gave it a couple of flicks – and Philipson, too – just the way they mixed the paint on the palette and applied it.

He railed against the system when the old ethos of the art school was being dismantled in favour of a pseudo-university. He wanted none of their respectability and academia – he hated all that. I can't remember how many times it was said they were coming to sack him. I've heard three different stories of Barnes deciding to get rid of him and a couple of tales of Davie on the brink of resignation. One deputy director, instructed by Barnes, was allegedly sent to deliver the brown envelope with the P45 – or, as another version of the tale has it, news of a disciplinary cut in salary. Davie had been tipped off and got in a bottle of whisky. The messenger was a known tippler, and when the bottle was empty he left without delivering the brown envelope. That was that. Davie had seen them off.

I've witnessed Davie tearing up his morning mail in the gents, before going up to his studio. He'd be standing there having a pee and throwing the mail into a tin wastepaper bucket. He had another filing system – a big dresser in the studio, stuffed with official correspondence he hadn't even read. He rarely went to meetings, especially if it was the academic council. He was quite philosophical. 'I'll tell you what's going to happen,' he'd say. 'Nothing's going to

happen.' Then for hours on end he would philosophise about how art schools had gone wrong.

Davie seemed to have only a vague sense of what he wanted done in the school. Students should be taught drawing in a Scottish tradition that respected the Masters. He told me he didn't like the way that most people drew in Glasgow. There was too much atmosphere and not enough clarity. Although he was a poetic impressionist, he wanted Florentine precision. There is a thing, certainly among good ex-students of Davie's, about attacking the white canvas with your brushes. Never mind preparatory sketches: pull the picture out of the paint. It's a macho Glaswegian thing. You can always scrape it off and do it again; but, nevertheless, there is a dare involved and the possible elation of getting it right.

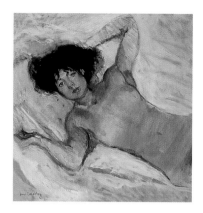

64. Annette, 1981

Davie petrified a lot of students, even grown men who'd spent years in the shipyards. If they were attacked in the street by a seven-foot thug they would probably give him a thrashing, but they were scared of wee Davie. He would shout at them and didn't think twice about taking a brush out of their hand and changing their painting. That was teaching by demonstration.

I don't think I can remember a single day when Marysia wasn't in the school. She was a fanatical supporter of David, forever singing his praises. But they fought like cat and dog. One day we were called to a serious staff meeting. Davie poured us all one of his minuscule glasses of whisky and began to explain some impending crisis. We were all listening intently and suddenly the door bursts open and in walks Marysia. 'David, you little shit!' He says, 'How dare you come in here, Marysia, this is a fucking meeting!' I was standing near the window, listening to this craziness. The next minute he shouts, 'Sandy, how dare you look out the fucking window during a staff meeting!' Some staff meeting.

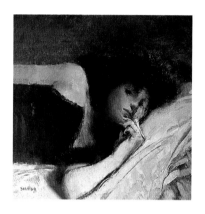

65. Annette, 1981

He was always charmed by an attractive young female student. Definitely a character in that area. He's always got something to say of a pretty girl. He spotted an attractive young woman in the Arts Club one day and said to me. 'Y'know, at my age I cannae really get any young women. When I was younger, of course, I had all these women, but the problem was I didn't really know what to do with them. Now that I know, I'm too old.' He spoke quite bluntly about sex, handed out advice.

I always got on very well with David. Most of the other people he worked with had been his students or had come through the system. He knew them too well, knew their limitations. I was from another country. He confided in

me. We had quite a lot of heart-to-hearts. He'd call me up in the afternoons and give an account of himself. It was fascinating stuff. I learned a lot just listening. I'd never really met a Glaswegian artist of his generation who had worked through the '30s. He was an education for me. And there is no question he took me under his wing during his last three and a half years. I was younger than all the other staff.

The curious thing was that he almost took up an establishment attitude towards me. In his own mind he was a rebel but he always had a go at me for being a socialist. 'You're nothing but a communist, Sandy, and we saw your crowd off years ago.' There was a lot of banter about that. I was standing in the Arts Club and he came marching in saying, 'Sandy, you're a communist, and I have nothing to do with communists, so I won't be speaking to you today,' and off he went into a back room. He was actually collecting a couple of big smoked salmon, didn't want anyone to know about them, and stuffed them up his zipped jerkin. Out he came, having another go at me, very animated about communists. The next minute the smoked salmon crashed to the floor. Even he saw the funny side of being caught at whatever he was up to and immediately bought me a drink.

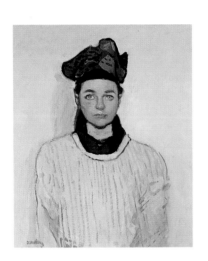

66. Caroline with her Mother's Hat, 1990

I've met very few of Donaldson's generation in Glasgow who really take art seriously . . . in the sense that, if you take art seriously, you're bound to be a bit of a poseur. It's much easier it seems, just to have a laugh about it. They actually believe that people in the capital sit endlessly at dinner parties, spouting meaningless rubbish about art. Davie, who should be there, is back in his studio, stripped to the waist, getting on with painting. So in a way all these older Glaswegians belittle themselves, don't do themselves justice. They'd rather joke than talk about Rembrandt. It's the opposite of, say, Bellany. Mention anything to John and it's, 'I was thinking about Shakespeare last night and I see him the same way as I see Picasso and Matisse, that's what I'm trying to dae, they're up there, and I want to be with them.' Nobody in Glasgow would ever say anything like that.

Donaldson is undoubtedly a tremendous painter. Very gifted. A phenomenal talent. He's painted scores of very special portraits. We've never seen his entire *oeuvre* put together. I wonder how he'll be regarded maybe a hundred years from now. As a Scottish portrait painter he'll probably be the best of the century, certainly better than Westwater, and Hutchison, who started him off. I think he'll see them all off.

BIBLE STORIES AND OTHER TALES

It used to be said of the Scots: 'scratch one and you'll find a theologian', and certainly, even in the latter half of this century, it was never difficult to find a meenister *manqué* lurking behind many a secular façade. It's not uncommon to come across literate, intelligent Scots who have extensive knowledge of the Bible but no belief in Christianity. Then again, the bunneted man on his fifth pint of the night in a Maryhill pub, who could quote you the forward-line of every Partick Thistle team since 1950, is also likely to be the hostelry's most erudite authority on comparative religion. Knox and his reformers have a great deal to answer for – especially in a man of Donaldson's age, and even more rampantly in one who breathed the brimstone fumes of a Scottish Baptist childhood. 'It was a lonely experience – no flowers, no decoration – and apart from the singing and evangelical fervour it was absolutely stark.'

The real fear of the fiery furnace did not persist beyond Donaldson's teens, and in many ways he learned to enjoy being a reprobate; but the haunting imagery of Christianity in Coatbridge, its rum-te-tum hymns and communal rituals, and above all the cadences and ornament of the King James version of bible stories have never left him. They charged his imagination as a child and challenged his creativity as an adult image-maker. He would have been a follower of Giotto in the *quattrocento*, of Cranach in fifteenth-century Germany, of Bruegel in sixteenth-century Belgium, and Goya, Delacroix and even Stanley Spencer in the long chain of European painters whose fires were fuelled by poetic allegory.

Baptist teaching might never match the ferocity of Jesuit indoctrination, but

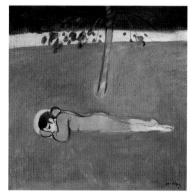

67. Christ in the Wilderness, 1972

it bites deep, stimulates conscience, and can turn guilt into an open wound which never quite heals. It is also capable of being one of the more joyful denominations, welcoming sinners saved for Jesus with hearty hallelujahs.

Whatever commitment he made to Christ when he was a boy, Donaldson now professes no Christian faith.

I think I shall die unshriven. The message is not reasoned enough for me. I just can't accept its discrepancies. As for the threat of retribution in the afterlife, I think it comes before you die. Seriously. I really believe the sins of the father are not visited on you so much as residing in you all the time. I think that we, as a nation, believe that the hell of one's mind, our private hell, is enough for anybody. If there is, indeed, another side, I hope I don't see any of my family there. Oh, come on – 'I thought this Christian idea was all about peace. What are *you* doing here?'

I suspect that – like Brendan Behan and a great many other backsliders – Donaldson is a 'daylight atheist'. He breaks the Third Commandment every half-hour of most days, has broken most of the other nine at one time or another, and probably subscribes to that eleventh, and peculiarly Scottish injunction, 'Thou shalt not be found out.'

68. The Nativity, c.1945–46

Scottish humour is at its characteristic best when it is being most reductive

– '. . . *Him* write a play, paint a picture, make a movie? Christ, I kent his faither.' His speech is spattered with Old Testament proverbs and New Testament homilies which he twists out of context to raise ironic or derisory laughter. He talks about 'the dirty bits' of the Old Testament 'leaping about in the dark recesses' of his mind, and suddenly remembers a picture he has always wanted to paint of King David – as the student song articulates, 'he was a dirty beast' – dancing irreverently in front of the altar. King David's seduction of Bathsheba, and how he ordered her husband into the forefront of battle to make sure he would be killed, tickled his mischievous fancy enough to express some elements of the story in paint. David Donaldson admires King David as 'a fly bastard', but, as an old religious Jewish gentlemen reminded him, 'the Lord gave him his comeuppance at the end'.

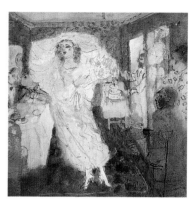

69. The Bride, 1980

The most wonderful story I've tried to paint and consistently failed is called *On the Third Day*. I never remember which part of the Bible it comes from. In Glaswegian, the story starts with a real shower of bastards jumping about somewhere in fairyland and they camp outside a town occupied by Jewish, Benno Schotz people. It came to pass, as they say.

On that nice evening, this crook from the crowd who were waiting to pillage the Jewish town was walking among the ripe corn when he espied this beautiful damsel, or wumman, and he says, 'Ho! ho!' So down among the corn they knew each other, to use the biblical phrase, and there the story should have rested. But somebody clyped. Had not the Jewish chief's daughter been ravished by these bastards from Dennistoun? And lo! The Jews jump up and down and call a meeting with Benno Schotz. There is great anger about.

Then somebody says, 'Wait a minute Jim, don't get too angry. These are wealthy bastards down there. We'll parley and come to terms.' And so it came to pass that there was agreement: they would trade with each other and make a few bob. What did the chief's daughter matter in these circumstances? The peace treaty was duly written down, and they were going to have a great time.

However, the Jews had agreed to do business only on condition that every Dennistoun man got circumcised. Somebody from Dennistoun said, 'Actually, lads, we're gonnae lose only a wee bit of ourselves here, we'll be sore for a day or two, but it's cheap at the price.' And then unfolds one of the most terrible stories in the Bible, and it comes from the Jews. 'On the Third Day, when they were sore, we fell upon them with the sword.'

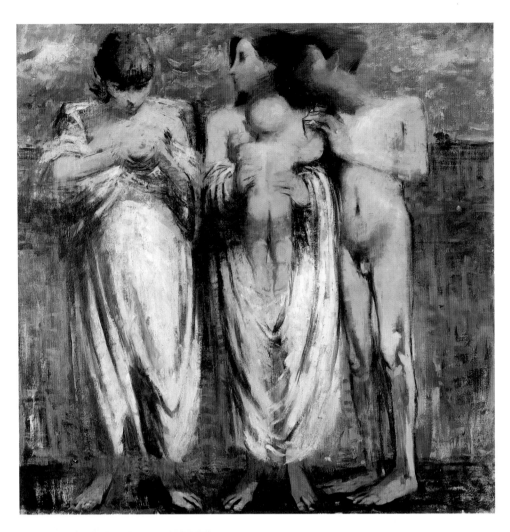

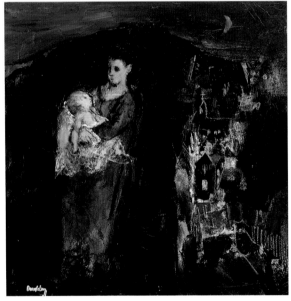

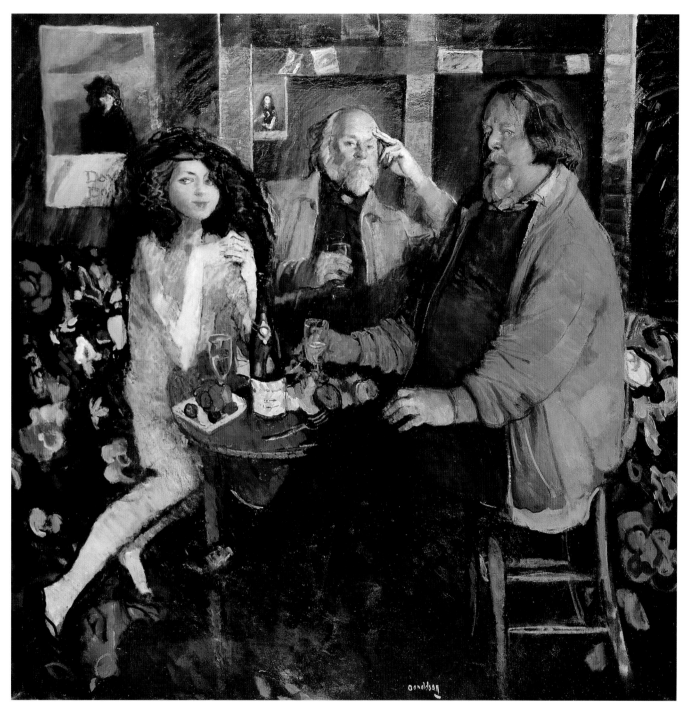

72. Annette and the Elders,
1980–81

I've tried to say all that in a painting. I've always thought I could do it better, then ballsed it up and had to rephrase it and mess it about. I solved the problem by having some guy alongside four people carrying a dead bastard, or a sore bastard, on a white tablecloth. There's a version in South Africa which is not very good. I'll try to do it again.

He is audacious in his attempts to translate convoluted biblical narrative and parable into visual images, and sanguine about how well his painted story will be read. A fragment of Genesis, 'a beautiful idea about Cain and Abel five days after the Flood, when the Lord whispered in the ear of one of the brothers and suggested how their tally of sheep might be evened up', was, he says, more accessible than many of his more complicated compositions. Guilt interests him, if only because he wonders if, without the arrival of Christianity, mankind would have had to suffer its burden.

73. Jesus Walking on Loch Lomond, 1994

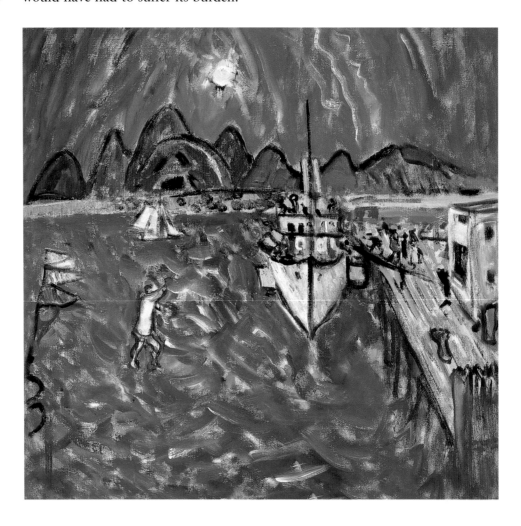

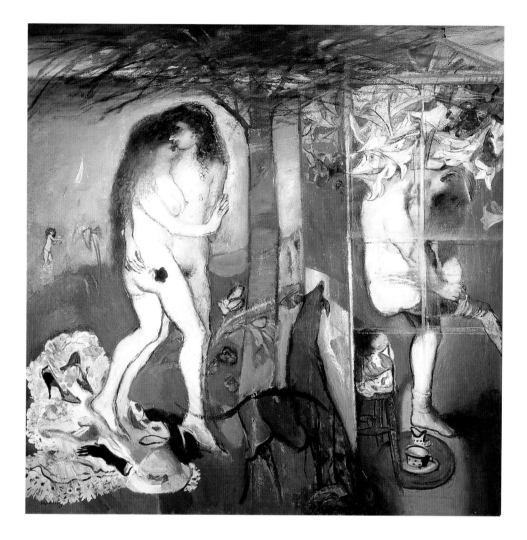

74. Lot and his Daughters, 1984

Guilt should never have been there. The thing I want to ask those eminent scribes and elders of so long ago is: what would have happened if Adam and Eve had just stayed in the garden all the time? They'd have been bored out of their minds, but enjoying themselves, having a great time. I painted Adam jumping up in the sky, his feet off the ground, and he's clutching an apple. Eve is standing upside-down. The point I'm making is that there must have been at least five minutes of some sort of cairry-on between them before the snakes were allowed in.

At one time or another he has interpreted the punitive Ten Plagues of Egypt from the Old Testament book of Exodus, most powerfully *The Plague* (1951, Plate 70) in which three adults and a child are afflicted by the Lord's curse of boils in a plaintive tableau, and a more delicate rendering in pencil and watercolour

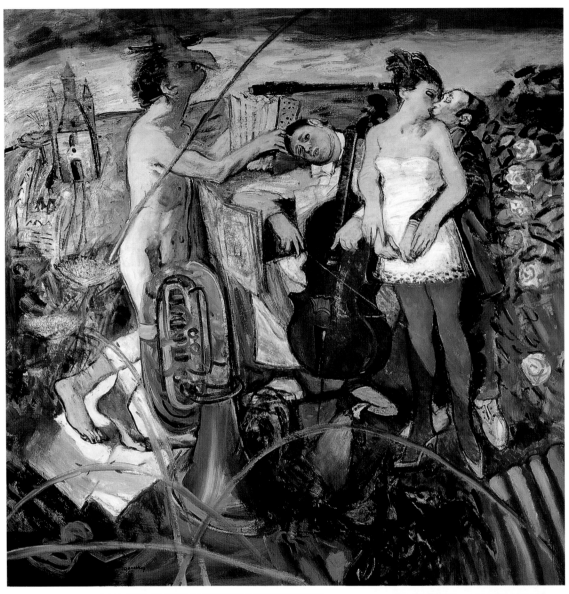

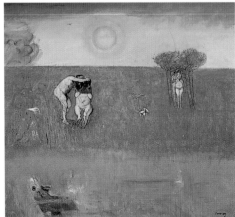

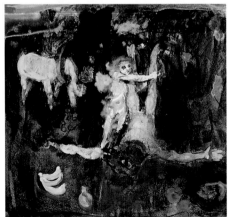

ABOVE
75. Cutty Sark, 1993

RIGHT
76. Tobit and the Archangel,
1990

FAR RIGHT
77. Midsummer Night's Dream,
1978

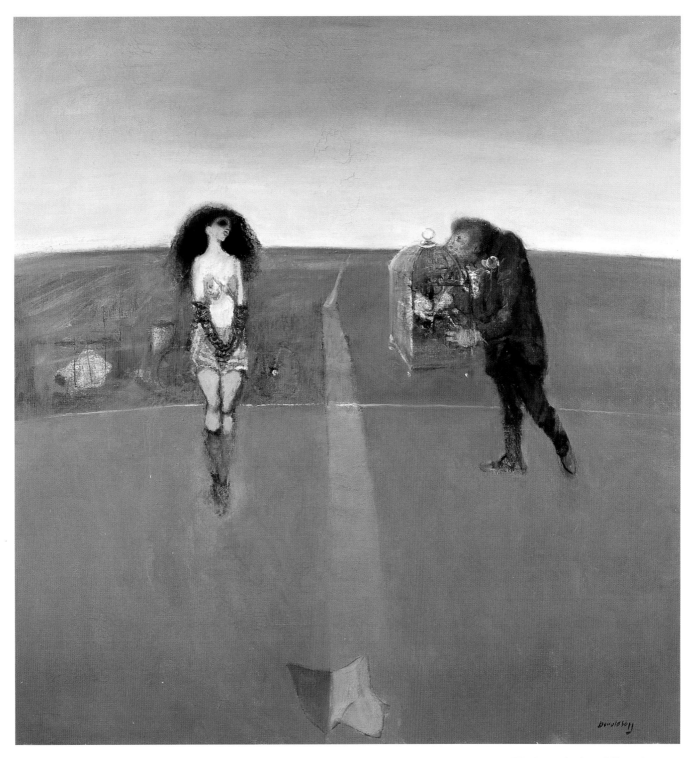

78. Cutty Sark and Tam o'
Shanter at Maryhill, c 1980

of *The Plague of Locusts* (1972). *Exodus II, The Flight from Egypt,* from the same biblical source, was painted around 1971 (Plate 71).

Over many years, like Renaissance and many later artists, he has interpreted the apocryphal Old Testament parable of Susanna and the Elders. She was accused of adultery by prominent members of the Jewish community in Babylon after she had spurned their sexual advances. Daniel proved her innocence and the Elders were put to death. It is very likely that two of Donaldson's many versions of the story will be regarded as among his finest figurative works. *Susanna and the Elders* (*c.*1978–82, Plate 1), much altered on its way to the finished canvas, is a lyrical yet sinister rendering of the tale, with the beautiful dark Susanna screened by rushes as she bathes naked. The Elders peer furtively, and one holds a cat as a symbol of their corrupt deceit. *Annette and the Elders, James and John (The Luncheon Party)* was painted between 1980 and 1981 while the other painting was still on its way (Plate 72). This is a glorious parody, involving two of Donaldson's oldest friends and colleagues at GSA, the artists James Robertson and John Cunningham, with Annette Carberry, Donaldson's favourite model for many years. The painting originated as a sketch at one of David's studio luncheons, merry affairs at the best of times, and on this occasion the genesis of a superb composition involving three intriguing portraits, a complex and decorative interior, a still-life of wine and fruit on the table and – as reinforcement of the way he felt at the time – a poster print of the artist's *Self-Portrait in Winter* overseeing the room.

Among other biblical subjects which Donaldson has investigated are the *Nativity* (Plate 68), *Christ in the Wilderness* (Plate 67), *Jesus Walking on Loch Lomond* (Plate 73), *Lot and his Daughters* (Plate 74), *Tobit and the Archangel* (Plate 76) and *The Marriage at Cana* (several times) since 1938. That year he embarked on a 7' x 4' canvas proclaiming that *The Kingdom of Heaven Is At Hand* – a Coatbridge Baptist text if ever there was one, but very obviously owing its graphic narrative style to Stanley Spencer's *The Cookham Resurrection*. A sketch of *The Kingdom* survives, but the painting was destroyed.

Donaldson regards the King James version of the Bible as one of the great poems of the English language. 'It's the Desert Island Discs situation, isn't it? You get the King James version and Shakespeare. All the rest you can throw away. If you want real knowledge, that is. You can't get knowledge without beauty.' He has tackled Shakespeare, too, in a scene from *A Midsummer Night's Dream* (Plate 77), and has had a long love affair with the antics of *Tam o' Shanter*

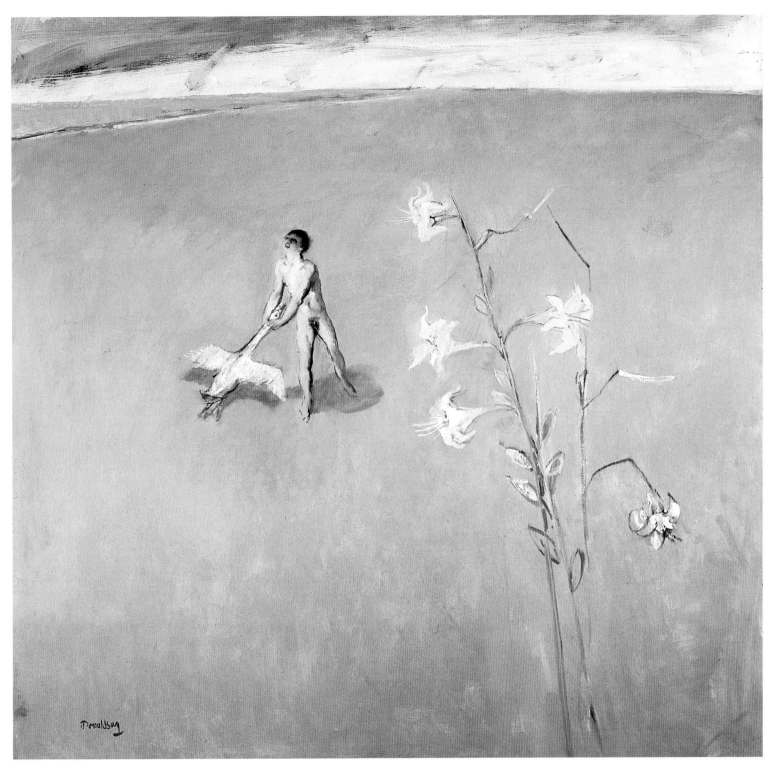

79. Rage, 1972–73

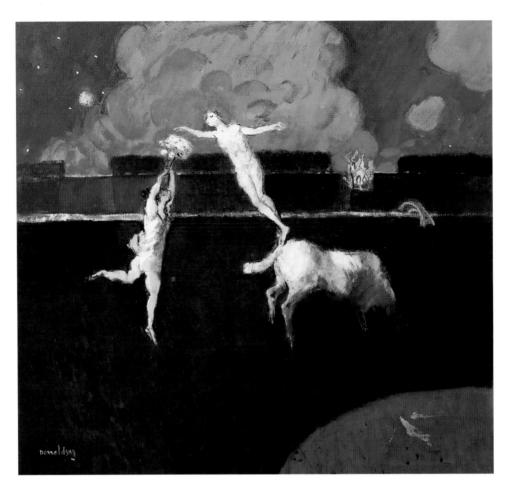

by Robert Burns (Plate 80). A 6' x 6' version of *Cutty Sark* was completed in 1993 (Plate 75), but one of his most challenging responses to the tale of Tam and the 'winsome wench' witch is *Cutty Sark and Tam o' Shanter at Maryhill* (*c.*1980, Plate 78). Donaldson believes that Burns was reworking the legend of Beauty and the Beast and set the pair in an urban wasteland on a typically Glaswegian Friday night when, as he says, 'anything can happen'. Cutty Sark is a mini-skirted raver and Tam a blootered yobbo.

Another important figure study is *Rage*, in which a naked but androgynous youth appears to be strangling a large white bird on a barren beach (Plate 79). A first glance might suggest it was some variation on the theme of Leda and the Swan, but the bird is a goose and murder, rather than sex, is afoot. Spikes of pale lilies thrusting through the foreground give the composition a daring dynamic. Donaldson has said the painting expresses his rage at the impermanence and destruction of beauty – 'even the lilies of the field fade'.

MARYSIA AND FRANCE

Donaldson married Marysia (Maria) Mora-Szorc in 1948. She was a student at GSA – 'a wee Polish girl with an incredibly attractive accent', he says affectionately – very beautiful, already his model, whose delicate, elfin features and studied elegance would be the subject of scores of Donaldson paintings over almost half a century.

At the age of eight Maria saw bombs blast out the windows of her home. The family fled across Europe, shot at by Russians and Germans. Like many young refugees, girls as well as boys, she found some of the excesses of war exciting – even the London Blitz.

She was a clever student and intensely clever in many other ways. A kind of free-thinking Roman Catholic as distinct from a Protestant pape. In our time we had many fine houses and it was Marysia's knack, her gift, to make the most of them. She was, and is, a first-class designer. She was particularly creative with clothes, not a manufacturer, but then she was never supported by the kind of persons she needed. A new concept of knitwear is being regarded today as a discovery. Marie was doing it forty years ago.

I admit that I was too deeply involved in all kinds of capers. But I never saw business as an option. She was determined to try, and I didn't give a bugger what she did. I didn't promote her. If the truth be told, I wanted her out of the road because her business ambitions interfered with me.

Marie, who is basically a continental, always had difficulty understanding the nuances of Scottish life and my kind of life. I think she felt an outsider. I realised her dilemma, trying to integrate, always trying to force herself into a culture which was foreign to her. She was a doer. She should have been an architect, or a general in the Polish cavalry – one or the other. She was an organiser. We bought various properties in France before finding, in 1980, a beautiful old farmhouse at Montjoi in Lot-et-Garonne. I still had my migraine,

81. Chaudière, 1972

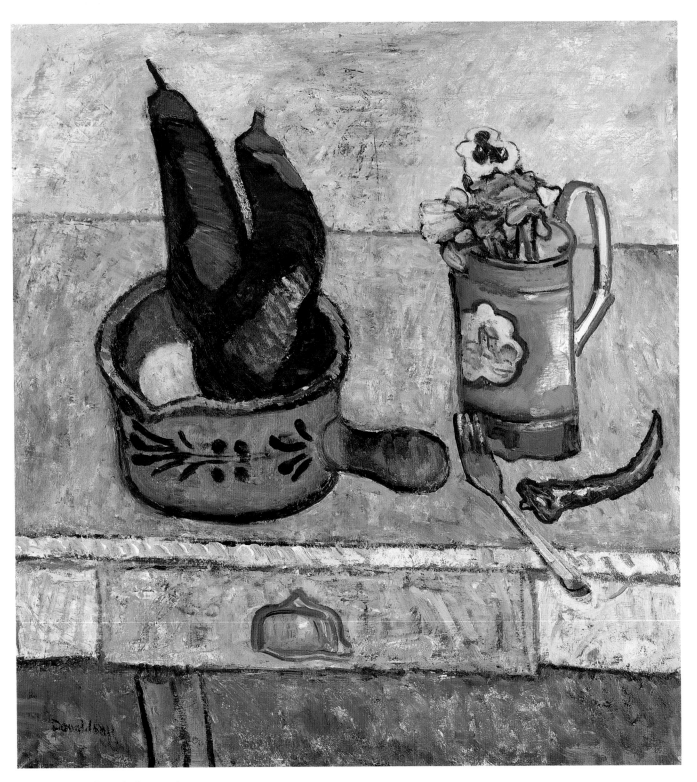

82. Still-life at St Roman de
 Malegarde, 1991

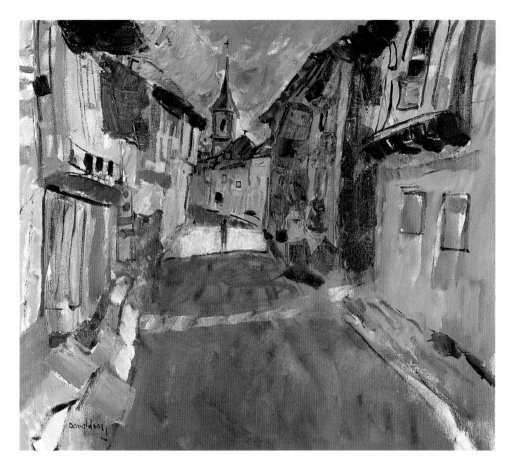

then they diagnosed diabetes. We soldiered on, not entirely happily, because nobody can live happily with me.

83. Montjoi, 1982

When their daughter Caroline came to live with them in France – where they finally settled at St Roman de Malegarde in Provence – Donaldson built her a swimming-pool, screened by a plantation of mature olive trees. It was, he says, a 'she's-so-far-from-the-sea, poor-wee-soul fit of generosity – millionaire's row stuff'.

One way and another a marriage 'always full of tempests' turned seriously sour. 'Marysia handed me the frozen mitt.' They had thought that living in France would help. He retired from GSA in 1981. 'I didn't want to be yesterday's man in Glasgow.'

84. Cool Day, St Maurin, 1982

It seemed that living at Montjoi, where he had a huge studio and painted many superb French landscapes, where Marysia also wanted to paint, would work to their mutual advantage. He now realises that he failed to anticipate that he could stand living in France 'for only two weeks at a time'. He did not travel well. 'If I was taken to Rothesay I wanted back the next day.'

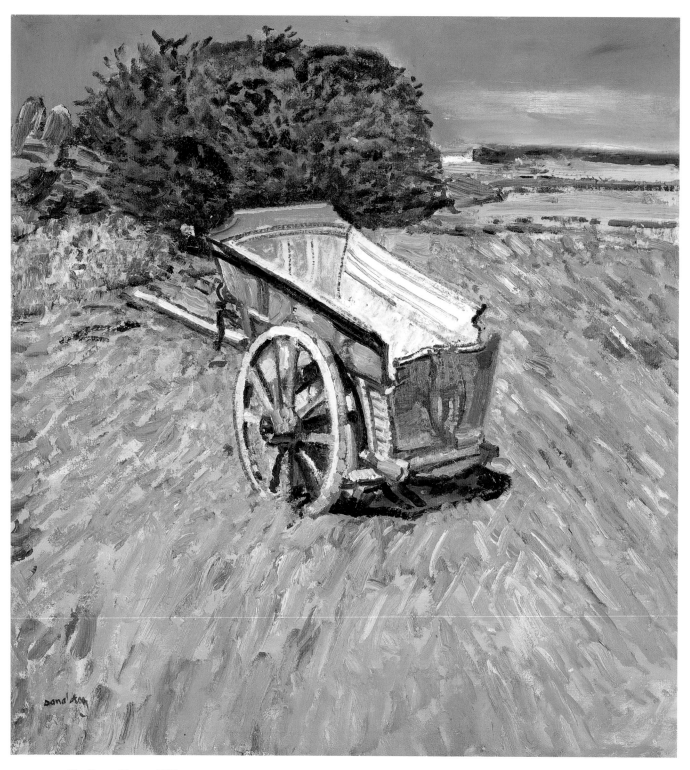

85. Carte Bleue, 1990

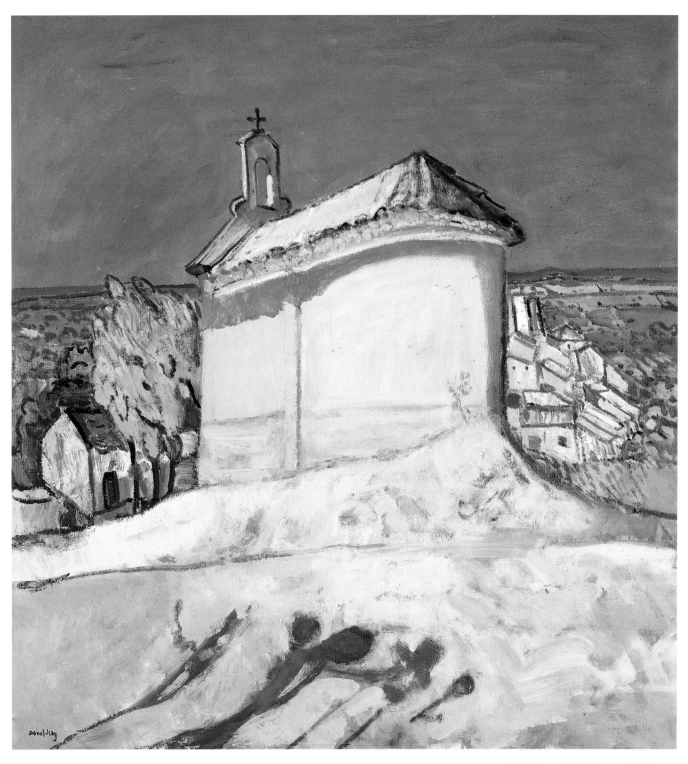

86. Church at Buisson, High
Summer, 1990

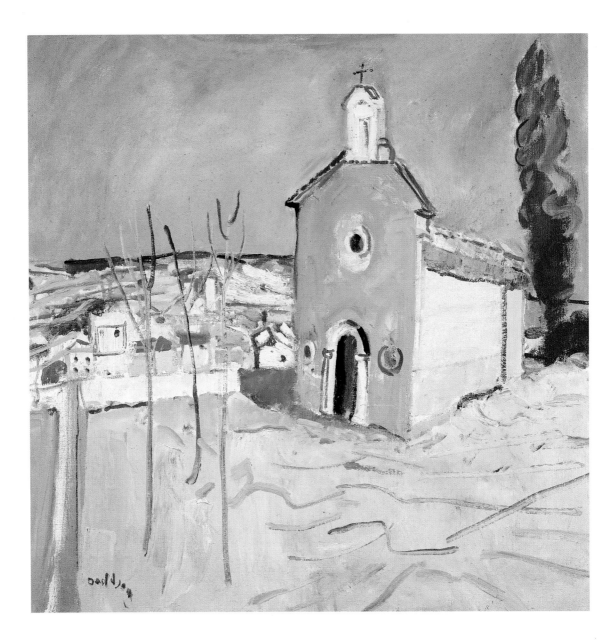

87. Church at Buisson – Bitter
Day, February, 1990

Marie was perfectly happy to stay in France for the rest of her life, which she is doing now. I didn't cut her off without a penny or anything like that. We're not divorced. I pay all her monthly bills. She did so much more for me than Kate, but in both cases it was the wrong idea.

Donaldson knows that some of the best landscapes in his career were painted in France. Like all north Europeans, particularly Scots who have to endure more

than their fair share of sullen skies and biting winds, the tawny earth and high cerulean blues of southern France and the bounce of the sunshine lighten heart and palette simultaneously. The first morning Vincent Van Gogh awoke in the Midi, he saw and painted a tree in blossom with its head in the sun and its feet under snow. From that moment his work never returned to the sombre browns and muted tones of his Dutch and Paris periods. More than a thousand miles south of Glasgow, Donaldson knew no such dramatic metamorphosis, but his brushes danced to different rhythms in France and his colour sang jauntier tunes. His Scottish landscapes, richly green and dense in texture – the paint sometimes slabbed with a palette knife – gave way to more open and airy canvases, glittering and expressionist responses to harsh light on parched earth and bleached scrub. His magnificent *Olive Trees, Pierrelongue*, painted near Orange in the Drôme valley, is the ultimate in harmonic susurration (Plate 89).

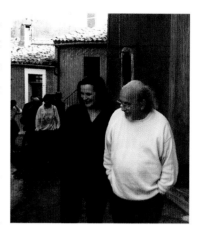

In France with Marysia

88. Buisson, 1990

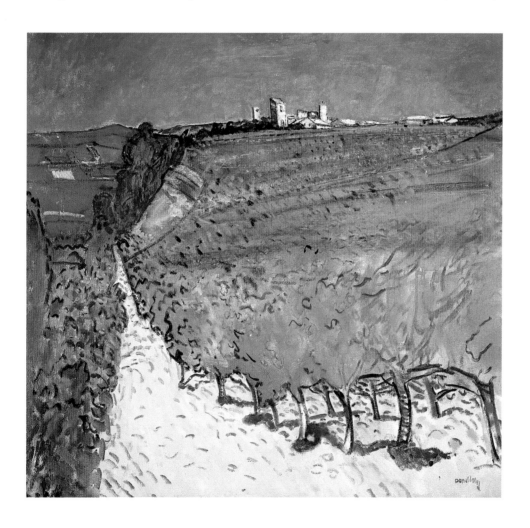

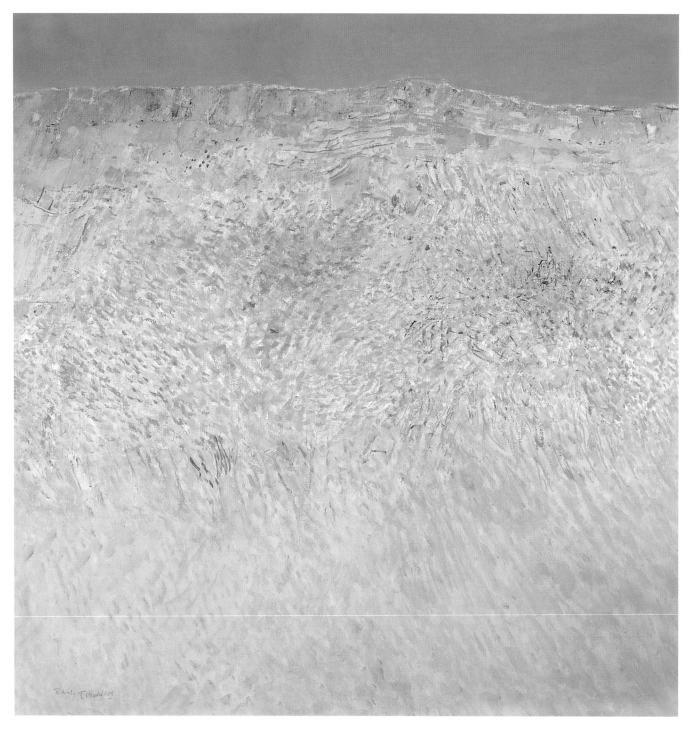

89. Olive Trees, Pierrelongue,
c.1975

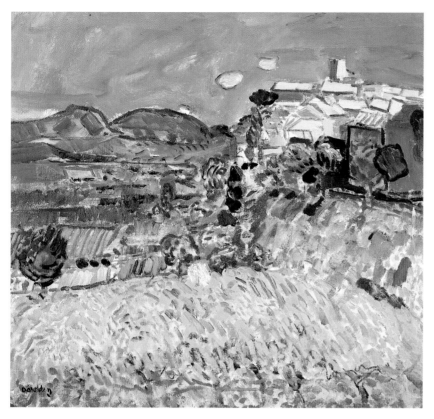

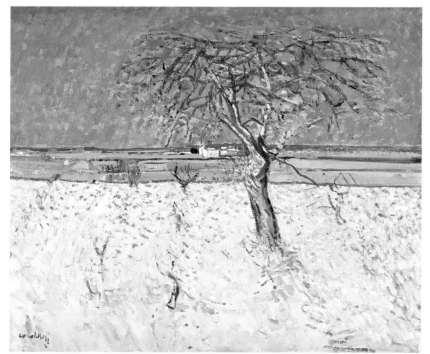

ABOVE LEFT
90. Villedieu, 1990

ABOVE RIGHT
91. Peach Tree, 1990

LEFT
92. Road to Cairanne, 1990

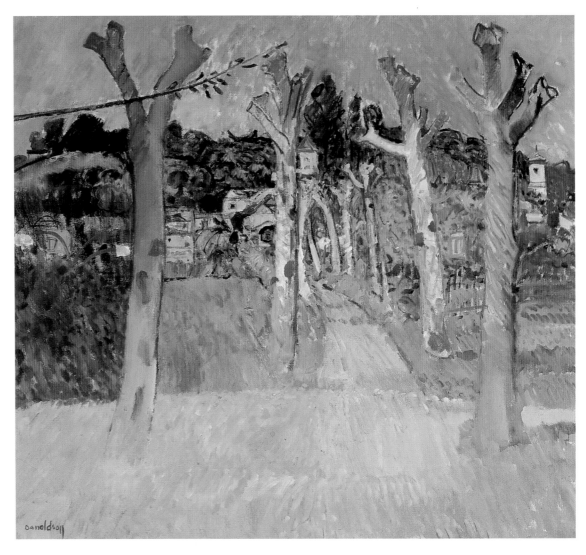

RIGHT
93. Pollarded Trees, St Maurin,
1982

BELOW LEFT
94. St Maurin, 1990

BELOW RIGHT
95. St Maurin, 1988

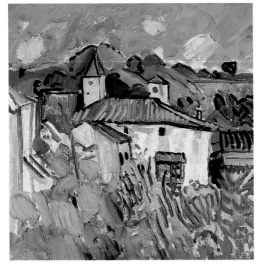

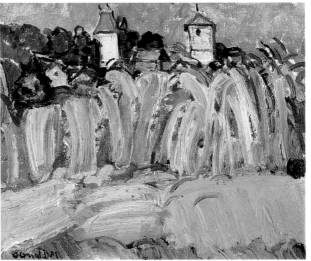

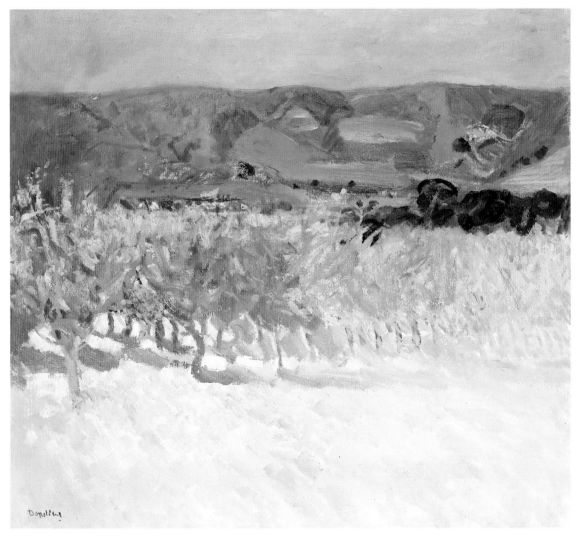

LEFT
96. Peach Trees, Pierrelongue,
c.1977

BELOW
97. Mountain Thistle, Drôme,
1972

'It was an attempt to create in paint the noise of the olive leaves moving' – as challenging in execution as trying to paint the rustle of a taffeta skirt. Even his still-lifes, portraits and interiors took on a brighter presence, finding new delicacies even in saturated colour, reverberating with fresh intensity.

There are several photographs of Donaldson at work on a painting, often half-naked, stripped for action. One picture in particular seems to show us much more than a wee bald man in striped semmit and shorts standing in front of an easel in a tangled French garden. A village scene has been begun on the canvas. He is oblivious of the photographer – of everything except that rectangle of space before his eyes. He is poised like a wrestler ready to spring at his opponent, feet apart, knees slightly bent, heels just off the ground, a clutch of brushes bunched in one hand. From this frozen moment of calculating concentration we

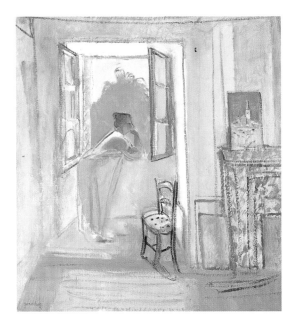

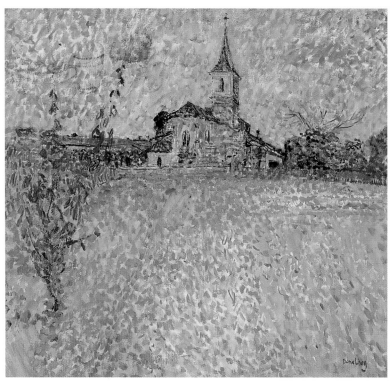

LEFT
98. At the Window, Montjoi,
1989

RIGHT
99. Church at Montjoi, 1984

begin to understand what he means by physically 'attacking the canvas'. This is the intensity of Donaldson, caught *en plein air* in full flood, summoning all the mysterious energies which pass from eye to head to heart to hand.

Many paintings were accomplished at and around the tiny ancient village of Montjoi. The little steepled church bore happy resemblance to the wee white-and-black kirk he painted at Drymen and used so often as 'a splendid note on the landscape'. But in Provence, where white horses – like that galloping creature of his creative imagination – are legendary reality, he was at last liberated from Scotland's 'inspissated gloom' and revelled in the landscape around St Roman de Malegarde. Donaldson was into his sixties when the move out of Glasgow to Drymen brought landscape conveniently within his reach. France offered fresh and more vivid horizons, and the French agreed with his own opinion of his work – 'as good as, if not better than, anything being painted there'. His pictures sold so well that Scotland never caught sight of them.

THE LAST WORD

Our conversations had been spread over many months – almost 200,000 words recorded and a long editing job ahead. David and his daughter Caroline, who lives with him in Glasgow, could not have been more hospitable. Caroline's son Sebastian, one of the most beautiful boys I have ever seen, was a happy and boisterous diversion. Sebastian and David have formed an exclusive mutual adoration society. The last thing I saw in the house, just before David waved us goodbye, was a small portrait of Sebastian, paint still wet, maybe finished, maybe not, but well past any threat of being scrubbed out. Donaldson's paintings of children have always been exceptional. There is no mawkish sentimentality about them. He in no way descends to them. They are what they are – little persons whose innocence and grace encourage the white horse to come out to play.

We spent most of the last session recapitulating, tidying up stray ends, filling in holes. He had not rehearsed any final thoughts but knew some were expected of him.

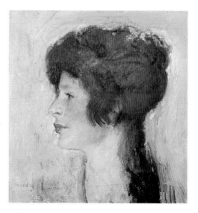

100. Marysia with Red Wig, 1983

Art is only one of the things that human beings do, but I don't expect to be remembered for anything else. A great guy came into the Glasgow Art Club one day, a psychiatrist, and I says, 'Hello, Jim,' and he says, 'Hello, David,' but in a sepulchral voice. I says, 'What's up, James?' and he says, 'The waters of eternity are lapping around my feet.' He was a distinguished doctor with a permanent five o'clock shadow, and he was indeed approaching the foothills of eternity. I share his feelings when I think about my life's work. Sadly, it hasn't been enough. There were too many mental breakdowns of one kind and another.

Of course there are days when I don't want to be remembered at all. But then I remember a painting of my daughter Caroline thirty-five years ago, wearing a silly party hat – it's in a New York private collection – and I think, among the work of all the great painters, it would take its place. That's not bad when I think of all the things I've done. I sold it at the Academy for very little,

beautifully framed. That frame was stolen in the sense that it was an old thing left kicking about the school. Nobody had the wit to see what it was. So I took it and left it out on a window-ledge of my great studio and let the rain batter it for a year. It was absolutely gorgeous. The painting and the frame are merged into something that is world class. Yes, it is world class and, yes, I would like to be a vain old bastard. There are one or two landscapes painted in France which are as good as anything that nowadays comes out of France. As far as I can see nobody in France can paint at all. I'm not placing myself alongside Cézanne, but there are one or two pictures which properly convey time, temperature, place – what it was like to be in the midday sun, and alive.

Yes, I suppose I would like something carved on my tombstone – how about 'HE DIDN'T UNDERSTAND IT AT ALL'?

You've asked me more than once if I've been given my 'place' in national and public collections – am I adequately represented? The answer is no, and the reason is probably my own fault. In the best Protestant tradition I probably got what was coming to me. I make no secret of thinking that so many people who make judgments about art are idiots. That's my opinion. The world seems to think otherwise. For me portraiture is the very crux of the matter. You can get away with anything in a composition, but with a portrait you are asking – rather foolishly, rather dangerously – for another kind of approval. I don't blame people one jot for saying it's not how they see the subject. How can it be? There are two ways you can react to that response. Either I'm wrong or they're wrong. I'm humble enough to think that often I'm wrong.

I used to think that the ultimate horror would be to have a tape that started running the moment you were born, and you were subjected to listen – say at the age of eighty– to every word you ever spoke. To a certain extent I do this in my Lutheran mind, in among the dark clouds, hearing only the bad bits. Nice people have encouraged me, said flattering things, but to no avail. I am haunted by my inadequacies – not being able to draw like Michelangelo or paint like Goya. You will have gathered that I think Goya was pretty good. I would have given him an honours degree in fine art, but when I reached the stage of handing out degrees and diplomas I realised that I wouldn't have given myself one. I didn't belong with those people who took the arts course as if it were medicine. I understood only too well why the medicine didn't work, and wouldn't have worked for me. Did I want a diploma? I've got a diploma. They gave me an honorary diploma.

David Donaldson, as seen by
Danny Ferguson

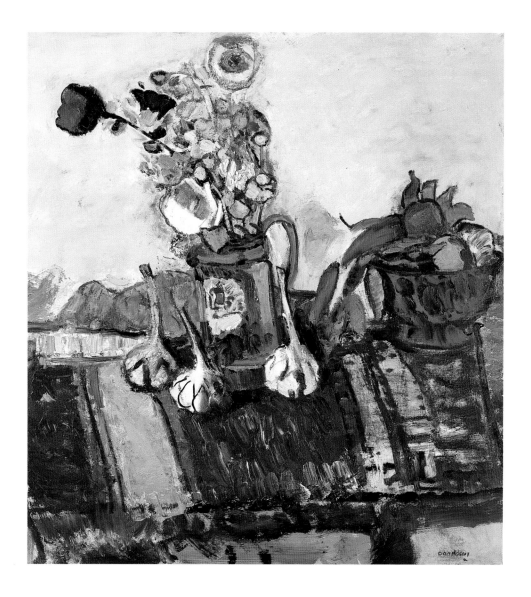

I think of Angus Neil who had a disturbance of the mind, which persons who are maimed at birth can't cope with, people who suffer from a sore soul. It would be right to say that I was not healed. I don't blame anybody. I must have been deeply affected by the circumstances of my childhood.

Here I am, approaching eighty, and remembering my mother, who I had not seen for twenty years, lying dying – blind and with one leg amputated. I know the reasons why I had not seen her for so long. They lie in that terrible Lutheran society of 1916, that polite hypocrisy of the Scottish working class. My mother was taken in as a servant. That was no delusion of grandeur. Why was she taken in? Old Mary, my grandmother, was no doubt tired bending to scrub the floor; but we're not talking about mansions, we're talking about

housing schemes. Meg, my mother, was taken in to be diminished, to show that she was nothing more than lower class, the scarlet woman who had brought disgrace to the family. She was a pretty woman – a nice woman, really – but feckless. And, after all, she had borne me at the age of sixteen, at that bad time in a terrible war.

One dreadful night, no doubt in extremis, she told me she was my mother. She had married my father and moved into a housing scheme with their two new children, my sisters. I had lived with the old Donaldsons until I was eighteen or nineteen. My grandfather paid my modest art school fees. By that time I'd struck up a comfortable relationship with the man, Bob, who had been my big brother for so long before he was revealed as my father. He was a nice wee man who many years later told me – and this is unbelievable – that he didn't know that the consequences of his lovemaking to my mother could be a child. Of course, it was his generation which marched off merrily to the Somme. He didn't, because he was too wee, too wee even for the famous bantam regiments, and besides he was in a protected occupation. I admired him because he was a good cricketer – that was at least something. He had two passions, opera and racing. He spent his money betting on horses, dogs, anything that would run. He was often broke. The main element of the man was his belief in the catechism. He had soiled life and therefore had to cleanse his soul. He was like that until he died at ninety-two.

David Donaldson in 1963

You must understand – and it must be difficult for you to accept – that these two people who were my progenitors, whom I never referred to as anything other than Meg and Bob, were nice couthy people who eventually bred nice couthy daughters. And the grandfather of this small working-class boy, old Dave Donaldson, took it upon himself to pay my fees at art school in order to make his peace with my father. He didn't give a damn what I did really, but clearly the family row lay heavily on him.

Slowly but certainly the art school trained me to be a bloody snob, as I remain to this day with two cars and two big houses and every fucking thing you could ask for.

I've had this terrible feeling during all these long sessions. I feel no sense of accomplishment – that, in the world's eyes, I am not a great painter. Yet I have still that nervous hope you asked about, that perhaps one day, by the grace of God, I might paint something as wonderful as Stuart Park's little pansy.

ENVOI

I am left with a mirage of images. Of that bitter winter portrait in a peasant cap which has some of the anguish of Lear raging against the storm on a blasted heath. Of Lord Macleod and Sir Hector Hetherington investigated so thoroughly and mysteriously in portraits which engage and disturb and match the great Viennese expressionist studies of Oskar Kokoschka. Of the child innocents – Caroline in a party hat and Sebastian as a beautiful sprite. There is nothing more honest in art than Van Gogh's portrait of the roly-poly *Le Père Tanguy* or Socrates in the person of postman Roulin, but Donaldson's *Sir Samuel Curran* and *Bobbie McIntyre of Sorn* are as forthright and spontaneously joco as anything realised by Vincent's frantic brushes.

We forget that the true Scottish meaning of the word glamour is 'a charm upon the eyes' – enchantment, witchery, by which they see things fairer than they are. Donaldson is, in that sense, a glamorous painter. He has the gift of necromancy. We see it in his adoration of women, in his soothsayer's interpretation of allegory, in the way his paint can bring *nature morte* to such radiant life and how it invigorates and makes particular the landscape of Scotland and France.

I see among so many images the side of a village house in France (Plate 102). A man 'hings oot' in the Scottish sense at an upstairs window. Immediately below, a naked female form stands at another window. A cat is asleep in the street. There is no other information, no sense of drama, no suggestion that anything is going to happen in this scene until the sun goes down. Why would anybody paint such a picture? It is not entirely fanciful to think that the man is the artist himself, that the woman is Marysia, that there is a distance between them, and that the cat, as cats do, minds its own business. All meaning is, however, irrelevant. It is a perfect example of how Donaldson the enchanter wondered what he would paint that day, needed to paint, and got on with it, happily scratching at an old and terrible itch.

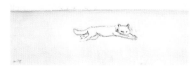

102. White Cat, Montjoi, 1986

Major exhibitions of his work have been too few and far between. He has sold all over the world, has good friends in high places, his work is stocked by many of the nation's best galleries, yet it has seldom received the concentrated critical attention that major shows automatically inspire.

The child has survived the man of so many distinctions and all the icons of his success: his Kelvinside mini-mansion, two Audi saloons at the door, his property in France. He brought from that Baptist childhood such a love of 'all things bright and beautiful' that almost inevitably it heightened an awareness in adult life that 'pleasures are like poppies spread – you seize the flow'r, its bloom is shed'. I frequently detect in his work a lament for transient joys, a requiem for fruits forbidden by Calvinist conscience and repented at leisure.

I enjoyed every minute with the man and months of listening to his voice. I was stimulated by his darting mind, garrulous honesty and raucous humour. And by his very Scottish capacity to get high on his own hyperbole. We share a deep distrust of academic art analysis, its imbecile jargon and poverty of feeling. I realised we shared many things. For a man who constantly calls himself thick and stupid he possesses, as he says himself in moments of bombast, massive intelligence. His dissertation on the painting of portraits should be quoted in every art school manual.

At the end of the day I was humbled by his humility. He is right to stand in such awe of Goya and Velazquez, but wrong to stand in his own shadow. History will celebrate David Donaldson's enormous contribution to the culture of Scotland and its visual arts. As a legend he will live for a long time; as a painter for much longer.

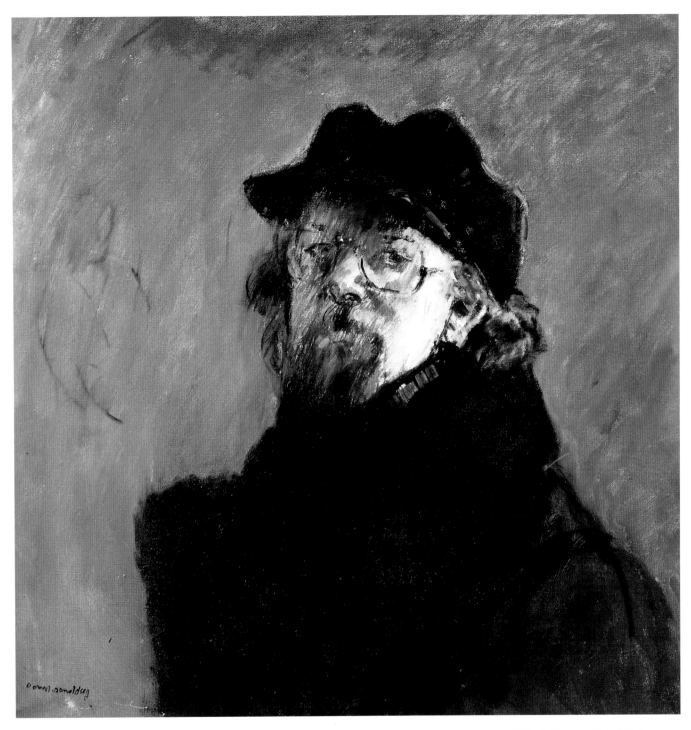

103. Self-portrait in Winter,
1978

ROYAL PAINTERS AND LIMNERS

The office of Her Majesty's Painter and Limner is honorary, for life, and unique to Scotland. Broadly similar royal positions – Painters-in-Ordinary – were discontinued at the end of the nineteenth century. It has been recent practice to seek the opinion of the President of the Royal Scottish Academy and other qualified persons before the Secretary of State for Scotland recommends an appointment to the sovereign. None of the commissions since 1723 has contained any reference to the functions of the office.

Although the records of Scotland mention some fifty painters employed by the Crown between 1300 and 1550 – decorating, painting buildings, ships and armaments – there are no references to portrait painters until the reign of James VI. The existing office was established in 1703 for reasons which are now completely obscure. George Ogilvie was commissioned by Queen Anne for 'drawing pictures of our person or our successors or others of our royal family, for the decorment of our houses and palaces, and for painting our said houses and palaces, and for doing all other things pertaining to the said airt'. There is no evidence of his work in any of those fields.

A salary of £100 was attached to the office from 1703 to 1830 when it was increased to £300 during Sir David Wilkie's lifetime. When he died in 1841 it reverted to £100. The Treasury succeeded in having the salary abolished in 1933.

At various times the office has been left vacant in the absence of a candidate of sufficient calibre. Since Ogilvie's death in 1723 the following have been royal Painters and Limners in Scotland: James Abercromby (1723–81) and his sons Alexander (1744–56) and Thomas St Clair (1773–1823) monopolised the post for a century; Sir Henry Raeburn was appointed in May 1823 but died two months later; he was succeeded by Wilkie (1823–41), Sir William Allan (1841–50), Sir John Watson Gordon (1850–64), Sir Joseph Noel Paton (1864–1901), Robert Gibb (1908–32), Sir David Y. Cameron (1933–45), and Stanley Cursiter (1948–76).

CHRONOLOGY OF THE ARTIST

1916	Born David Abercrombie Donaldson at Chryston, Lanarkshire
1932–37	Studied at Glasgow School of Art
1936	Director's Prize, GSA
1937	Haldane travelling scholarship, GSA; visited Florence and Paris
1937–38	Additional year's study at GSA
1938–44	Part-time teaching at GSA
1941	Guthrie Award, RSA
1942	Married Kathleen Boyd Maxwell (marriage later dissolved)
1943	Birth of son David Lennox
1944	Appointed full-time lecturer at GSA
1948	Married Maria (Marysia) Mora-Szorc
1950	Birth of daughter Sally Mora
1951	Elected associate member of the Royal Scottish Academy (ARSA)
1956	Birth of daughter Caroline Mary
1962	Elected full member of the Royal Scottish Academy (RSA)
1964	Elected member of the Royal Society of Portrait Painters (RP)
1967	Appointed head of the department of drawing and painting, GSA
1969	Moved out of Glasgow to live in Drymen, Stirlingshire
1969	Cargill Award, RGIFA
1971	Awarded Hon LLD, Strathclyde University
1977	Appointed Her Majesty's Painter and Limner in Scotland
1977	Elected founder artist member of RGIFA (RGI)
1980	Acquired house in Montjoi, Lot-et-Garonne, France
1981	Retired from GSA
1984	Returned to live in West End of Glasgow
1988	Created Doctor of Letters by University of Glasgow
1988	Bought property at St Roman de Malegarde in Provence
1993	Birth of grandson Sebastian
1996	Eightieth birthday celebrated with publication of this book
1996	City of Glasgow Lord Provost Award for the Visual Arts

SELECTED EXHIBITIONS

Solo Shows

1961	Henry Hellier's studio, Glasgow
1973	'Edinburgh Festival Exhibition', The Scottish Gallery
1974	The French Institute, Glasgow
1979	The Fermoy Gallery, King's Lynn, Norfolk
1980	The Mall Galleries, London
1982	'Edinburgh Festival Exhibition', The Scottish Gallery
1983	The Macaulay Gallery, Stenton, East Lothian.
1983–84	Kelvingrove Museum and Art Gallery, Glasgow, major restrospective, jointly with Scottish Arts Council, which toured to Edinburgh, Dundee and London
1990	'Some Time in France', The Fine Art Society, Glasgow and London
1994	'Objets Trouvés', Barclay Lennie Fine Art, Glasgow
1994	'David Donaldson', Everard Read Gallery, Johannesburg
1996	Major eightieth-birthday retrospective at University of Edinburgh's Talbot Rice Gallery and Glasgow School of Art

Group Shows

1964	'Edinburgh Festival Exhibition: Four Scottish Artists', Scottish Arts Council Gallery
1965	'Seven Scottish Painters', IBM Gallery, New York
1965	'Scottish Painting', Nice, France
1968	'Three Centuries of Scottish Painting', National Gallery of Canada, Ottowa
1974	'Scottish Artists', Bruton Gallery, Somerset
1975	'Summer Exhibition', The Scottish Gallery, Edinburgh
1975	'British Painting', Agnews, London
1976	'Five Glasgow Painters', Edinburgh City Museums at the Royal High School
1976	'Four Glasgow Painters', Kirkcaldy Museum and Art Gallery
1978	'Festival Exhibition: Painters in Parallel', Edinburgh College of Art
1978	'Crawford and Company', Third Eye Centre, Glasgow
1981–82	'Contemporary Art from Scotland', Scottish Arts Council tour
1983	'Recent Paintings by David Donaldson', The Fine Art Society, Glasgow
1986	'Ten Scottish Painters', Royal Academy of Arts, London
1986–87	'David Donaldson and Robin Philipson at 70' The Fine Art Society, Glasgow and Edinburgh
1988	'Summer Exhibition', Everard Read Gallery, Johannesburg
1989	'The Artist's Choice', The Open Eye Gallery, Edinburgh
1989	'Scottish Painters', Fosse Gallery, Stow-on-the-Wold
1990	'Edinburgh Salutes', The Scottish Gallery, Edinburgh
1990	'Contemporary Scottish Painting', The Open Eye Gallery, Edinburgh
1991	'Scottish Painters', Fosse Gallery, Stow-on-the-Wold
1992	'Home and Abroad', The Open Eye Gallery, Edinburgh
1995	'Scottish Painters', Fosse Gallery, Stow-on-the-Wold
1995	'Christmas Exhibition', The Open Eye Gallery, Edinburgh

WORKS IN MAJOR COLLECTIONS

Her Majesty the Queen
Aberdeen Art Gallery and Museum
Dundee Museum and Art Gallery
Edinburgh City Art Centre
Robert Fleming Holdings Limited, London
Glasgow Museums: Art Gallery and Museum, Kelvingrove
Glasgow School of Art
The Hunterian Art Gallery, University of Glasgow
The Lillie Art Gallery, Milngavie
Paisley Museum and Art Gallery
The Royal Bank of Scotland
The Royal Scottish Academy
The Scottish Arts Council
Scottish National Portrait Gallery
University of Strathclyde

and in many private collections in Britain, Australia, Europe, the United States and South Africa

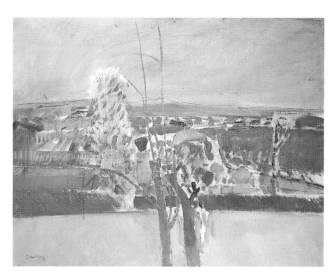

104. Early Morning, Drymen, 1982

LIST OF PLATES

48. *Edward Denny*, 1975 (44" x 42") (Private Collection)

49. *Marysia in C&A Pyjamas*, 1978 (48" x 48") (Collection of the Artist)

50. *Annette*, c.1977 (45" x 43") (Mr and Mrs R.A. McMillan)

51. *Lord Macleod of Fuinary*, 1966 (48" x 42") (The Iona Community)

52. *Caroline in a Red Hat*, 1990 (49" x 39") (Private Collection)

53. *Dugald Cameron*, 1980 (40" x 36") (Private Collection)

54. *Catriona*, 1961 (63" x 29") (Collection of the Artist)

55. *Self-portrait with a Delicacy*, 1993 (36" x 36") (The Duncan Family Collection)

56. *Self-portrait with Cactus*, 1974 (40" x 42") (Collection of the Artist)

57. *Self-portrait with Chef's Hat*, 1967 (29¾" x 19⅞") (Glasgow Museums: Art Gallery and Museum, Kelvingrove)

58. *Self-portrait*, 1986 (72" x 36") (Collection of the Artist)

59. *Kara*, 1982 (60" x 40") (Private Collection)

60. *Sally in a Moses Basket*, 1951 (30" x 25") (Collection of the Artist)

61. *Maid of the Loch*, 1980 (36" x 40") (Royal Bank of Scotland Art Collection)

62. *Macfarlane's Yard, Loch Lomond*, 1983 (36" x 36") (Mr John W.D. Thomson)

63. *Two Nudes*, 1978 (7" x 9") (Private Collection)

64. *Annette*, 1981 (33" x 33") (Mr R. Hill)

65. *Annette*, 1981 (21" x 21") (Mr and Mrs R.G.G. Anderson)

66. *Caroline with her Mother's Hat*, 1990 (26½" x 22½") (Collection of the Artist)

67. *Christ in the Wilderness*, 1972 (20" x 20") (Private Collection)

68. *The Nativity*, c.1945–46 (14½" x 10") (Private Collection)

69. *The Bride*, 1980 (13" x 13") (Private Collection)

70. *The Plague*, 1951 (40" x 40") (Private Collection)

71. *Exodus II*, c.1971 (18" x 18") (Mr and Mrs Giles Gordon)

72. *Annette and the Elders*, 1980–81 (60" x 60") (Private Collection)

73. *Jesus Walking on Loch Lomond*, 1994 (33" x 33") (Collection of the Artist)

74. *Lot and his Daughters*, 1984 (72" x 72") (Collection of the Artist)

75. *Cutty Sark*, 1993 (72" x 72") (The Duncan Family Collection)

76. *Tobit and the Archangel*, 1990 (35" x 39") (Collection of the Artist)

77. *Midsummer Night's Dream*, 1978 (10" x 11") (Private Collection)

78. *Cutty Sark and Tam o' Shanter at Maryhill*, c.1980 (42 x 40") (Barclay Lennie Fine Art Ltd)

79. *Rage*, 1972–73 (44" x 46") (Private Collection)

80. *Tam o' Shanter*, 1972 (28" x 30") (Private Collection)

81. *Chaudière*, 1972 (8" x 8") (Collection of the Artist)

82. *Still-life at St Roman de Malegarde*, 1991 (28" x 26") (Private Collection)

83. *Montjoi*, 1982 (30" x 34") (Glasgow Museums: Art Gallery and Museum, Kelvingrove)

84. *Cool Day, St Maurin*, 1982 (22" x 24") (Private Collection)

85. *Carte Bleue*, 1990 (28" x 26") (Lord and Lady Macfarlane of Bearsden)

86. *Church at Buisson, High Summer*, 1990 (36" x 34") (Private Collection)

87. *Church at Buisson – Bitter Day, February*, 1990 (30" x 30") (Private Collection)

88. *Buisson*, 1990 (34" x 36") (Harper Macleod Corporate Collection)

89. *Olive Trees, Pierrelongue*, c.1975 (36" x 36") (Private Collection)

90. *Villedieu*, 1990 (26" x 28") (Private Collection)

91. *Peach Tree*, 1990 (36" x 34") (Private Collection)

92. *Road to Cairanne*, 1990 (24" x 29") (Private Collection)

93. *Pollarded Trees, St Maurin*, 1982 (34" x 38") (Private Collection)

94. *St Maurin*, 1990 (14" x 14") (Mr and Mrs W.G. Lang)

95. *St Maurin*, 1988 (9½" x 11½") (Private Collection)

96. *Peach Trees, Pierrelongue*, c.1977 (36" x 40") (Private Collection)

97. *Mountain Thistle, Drôme*, 1972 (13" x 11") (Mr and Mrs P. Hooper)

98. *At the Window, Montjoi*, 1989 (25½" x 23½") (Collection of the Artist)

99. *Church at Montjoi*, 1984 (26" x 28") (Private Collection)

100. *Marysia with Red Wig*, 1983 (17½" x 16") (Collection of the Artist)

101. *Hollyhocks*, 1990 (28" x 26") (Private Collection)

102. *White Cat, Montjoi*, 1986 (36" x 28") (Collection of the Artist)

103. *Self-portrait in Winter*, 1978 (24" x 24") (Collection of the Artist)

104. *Early Morning, Drymen*, 1982 (27" x 35") (Collection of the Artist)

Every effort has been made to credit the owners of the paintings and photographs reproduced in this book. The publishers apologise if, by being unable to trace any sources, we have unknowingly failed to acknowledge ownership.

INDEX